הגדה של פסח

The JDC HAGGADAH

IN EVERY GENERATION

הגדה של פסח

The JDC HAGGADAH

From the Archives of "The Joint," the American Jewish Joint Distribution Committee

COMMENTARY BY ARI L. GOLDMAN
FOREWORD BY RABBI JOSEPH TELUSHKIN

DEVORA
PUBLISHING
NEW YORK◆JERUSALEM◆LONDON

In Every Generation: The JDC Haggadah
From the Archives of "The Joint," the American Jewish Joint Distribution Committee

Published by Devora Publishing Company
Copyright © 2010 American Jewish Joint Distribution Committee, Inc. All rights reserved.

EDITORS: Linda Levi and Ilana Stern Kabak
DESIGN: Viviane Tubiana
PRODUCTION DIRECTOR: Daniella Barak
COMMENTARY: Ari L. Goldman
HISTORICAL ANECDOTES: Ilana Stern Kabak
RESEARCH: Rebekah Marks Costin

Gratitude is extended to the team that lovingly conceived, researched, and brought this special Haggadah to fruition. In addition to those noted above, thanks go to Benjie Herskowitz, Carolyn Starman Hessel, Sherry Hyman and Abby Pitkowsky. We are also grateful to Steve Tarlow for his poetic translations on pages 76 and 77.

Hebrew texts used with permission of Davka Corporation copyright 1999, www.davka.com

Hard Cover ISBN: 978-1-934440-56-8 Soft Cover ISBN: 978-1-936068-13-5

E-mail: publisher@devorapublishing.com
Web Site: www.devorapublishing.com

Distributed by:

Urim Publications
POB 52287
Jerusalem 91521, Israel
Tel: 02.679.7633
Fax: 02.679.7634
urim_pub@netvision.net.il

Lambda Publishers, Inc.
527 Empire Blvd.
Brooklyn, NY 11225, USA
Tel: 718.972.5449
Fax: 781.972.6307
mh@ejudaica.com

www.UrimPublications.com

First edition. Printed in Israel

In celebration of our parents,
Heinz and Ruthe Eppler,
whose life voyages are represented
by the Haggadah story.

Their devotion to the JDC
has instilled in our family
a recognition of
the importance of its work
of Rescue, Relief and Renewal
of the Jewish People.

Knowing that these traditions have been practiced by generations of Jewish children and adults before us, in both good times and bad, makes us confident about the Jewish people's ongoing survival. Imagine what resilience it took for *Shoah* survivors to hold a Passover seder in a Displaced Persons camp in Germany. What was it like for the children of Russian refuseniks to learn the *Mah Nishtanah* in a transit facility in Italy? How did the Jews of Yemen transport their ancient Passover traditions to a new land? This book begins to answer these questions.

Reading through this Haggadah, the prayer that kept recurring in my head was the *Dayenu*, the famous refrain in which we remind ourselves of all that God has done for us, and then acknowledge that that alone would have been enough. Look through the photographs here, and the remarkable work of the Joint comes to mind as well:

If the JDC had only supported 58,000 orphaned Jewish children in Eastern Europe and Palestine after World War I, *Dayenu*, it would have been enough.

If the JDC had only provided support for the more than 110,000 Jews expelled from Germany and Austria by the end of 1938, *Dayenu*, it would have been enough.

If the JDC had only set up the agricultural settlement in Sosúa, in the Dominican Republic, to help escaping Jewish refugees from Europe, *Dayenu*, it would have been enough.

If the JDC had only supported 15,000 Jewish refugees in Shanghai during World War II, *Dayenu*, it would have been enough.

If the JDC had only furnished medical, educational and social services to the Jews interned by the British on the island of Cyprus after World War II, *Dayenu*, it would have been enough.

If the JDC had only financed Operation Ezra and Nehemiah, which brought over 100,000 Kurdish and Iraqi Jews to the newborn State of Israel in 1949, *Dayenu*, it would have been enough.

If the JDC had only founded *MALBEN*, a network of facilities and services for the handicapped, the elderly, and the chronically ill, arriving in great numbers to the fledgling State of Israel, *Dayenu*, it would have been enough.

If the JDC had only provided food for decades to hungry Jewish children in Tunisia, *Dayenu*, it would have been enough.

But the JDC has never been willing to say *Dayenu*. As long as there are poor hungry Jews in Kiev or in Casablanca, the JDC will not say *Dayenu*. As long as there are unlearned Jews in Moscow, the JDC will not say *Dayenu*.

To read this Haggadah and commentary and to look at these photographs is to be reminded of just how many lives the JDC has saved, and to be reminded of what an honor and privilege it is to participate in the holy work they do. "Thank you, Uncle Joint."

FOREWORD

by Rabbi Joseph Telushkin

In 1974, Rabbi Joseph Soloveitchik, the dean of modern Orthodox Judaism and a man who ordained more than 1,500 rabbis at New York's Yeshiva University, was invited to address a meeting of the American Jewish Joint Distribution Committee, otherwise known as either JDC or simply "the Joint."

It was a sensitive time. In the aftermath of the Yom Kippur war, both he and the leadership had a lot on their minds about the pressing needs of Jews both at home and abroad. Yet, when Rabbi Soloveitchik stood up to speak, he spoke not of contemporary issues but of two debts of gratitude, each over 50 years old, that he wished to acknowledge.

"During World War I, I walked past a *cheder* in Poland, and heard the young students singing, '*Got zu danken*, Uncle Joint'." Why? Because of the sacks of food, including cocoa, that the JDC had sent over to Europe. That day, a portion of the cocoa had been distributed to the *cheder* and it was the first sweets the children had tasted in years.

"The children drank the cocoa and it meant so much to them that they danced and sang, 'Thank you, Uncle Joint'," Rabbi Soloveitchik recalled.

And then, a second and very different sort of memory, this one about volumes of the Talmud. "When I was a child, I thought all Gemaras were old and ripped, with pages falling out. I never knew that a Gemara could be anything but a collection of tattered sheets. Once we went to visit my uncle Velvel, the Brisker Rav. At some point, he sent me into the next room to fetch a Gemara. I went, and couldn't believe my eyes. New Gemaras, freshly printed, clean, whole, no torn pages. I looked in the flyleaf, and there it said, *Matanah mei-ha-Joint*, a gift from the Joint. These two memories, Rabbi Soloveitchik said, "trouble my conscience because I never had the opportunity to say thank you to you. I must thank you for these two gifts before I speak to you today."

You are holding in your hands yet another *Matanah mei-ha-Joint*, a beautiful Haggadah with commentary and photographs that bring together the classic story of the Exodus with the modern story of the work of the JDC. As you turn its pages, you will be reminded, just as Rabbi Soloveitchik was that day in 1974, of just how much the Joint Distribution Committee has done for the Jewish body and soul alike.

This Haggadah is both old and new. Old in the sense that it contains every word of the traditional text that has guided and inspired Jewish life for generations. And it is new in the sense that it demonstrates, through vivid photographs and insightful commentary, how the seder and its themes continue to be lived and relived in our contemporary world.

The Passover seder is a practice that has impacted not only Jews but all humanity. Professor Michael Walzer of Princeton University has persuasively argued that the narrative at the heart of the seder, the freeing of the ancient Israelite slaves, has influenced more movements of social transformation and revolution than any other event in recorded literature. But for Jews, of course, the seder has far more than political and even spiritual significance. It is a ritual that has long brought the Jewish family and the whole Jewish people together, and one that has always shaped Jewish memories.

How many of us recall preparing and practicing the *Mah Nishtanah*, and the first time we stood up before family and friends to ask four of the most famous questions ever written? How many of us recall plotting to "steal" the *Afikomen* from under our father's seat, and planning the "ransom" we would demand to return it? How many of us remember inspecting with the most careful scrutiny the filled cup of Elijah to see if any wine was consumed during his annual and miraculous nocturnal visit?

INTRODUCTION

by Ari L. Goldman

"In every generation," the Passover Haggadah tells us,
"one should see oneself as having personally come out of Egypt."

That imperative might seem like a nearly impossible task in 21st-century America. We are very far removed today from slavery, miraculous rescues at sea and journeys through the wilderness toward the promise of freedom. But the reason that the Passover Haggadah still speaks to us so many centuries later is that its themes of liberation are repeated "in every generation" on both a national and personal level.

There is probably no better way of demonstrating the endurance of these themes than to look at the work of the American Jewish Joint Distribution Committee. Since it was established in 1914, JDC's mission has been to reach out to Jews in need of urgent help, to provide rescue, relief and renewal.

JDC was founded very much in the spirit of the Exodus story. Its founding mission was to free modern-day Jewish slaves. These slaves weren't building pyramids in Egypt, but were enslaved by poverty, ignorance, injustice, dislocation and discrimination.

There was no one solution for the problems Jews faced. The JDC needed to craft a response in every arena it entered: pre-state Israel, war-torn Europe, North Africa, the former Soviet Union, Cuba, India, Latin America and the modern State of Israel.

The idea of the JDC Haggadah is to tell and retell the ancient story of the Exodus through the modern rescue and relief efforts of the JDC. The JDC Haggadah includes the traditional text with English translations as well as instructions on the order of the service. Through vivid photographs, anecdotes and a running commentary, the ancient story of the Exodus and the modern-day story of the JDC emerge.

The JDC archives of tens of thousands of photographs have been made available for this project. The Passover themes, from matzah distribution and seder gatherings to washing, feasting and harvesting are depicted. The photos suggest the rich tapestry of contemporary Judaism — representing Jews of different colors and from different lands.

The JDC Haggadah reflects the breadth, depth, complexity and beauty of the Passover story and the role of the JDC in keeping it part of the continuing drama of the Jewish People.

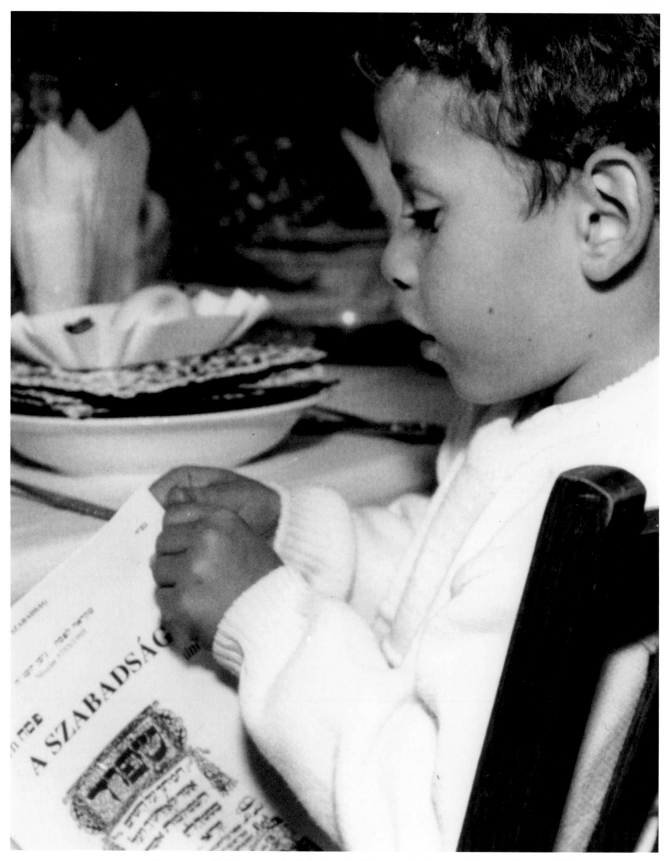

At a community Passover seder in Budapest, this youngster is eager to begin. *Hungary 2000.* Photo: Roy Mittelman

SEARCH FOR CHAMETZ

Before the search for chametz, on the eve of the seder night, recite:
BLESSED ARE YOU, Lord our God, King of the universe, who has made us holy and commanded us to remove all chametz.

בָּרוּךְ אַתָּה יְיָ, אֱלֹהֵינוּ מֶלֶךְ הָעוֹלָם, אֲשֶׁר קִדְּשָׁנוּ בְּמִצְוֹתָיו וְצִוָּנוּ עַל בִּעוּר חָמֵץ:

After the search, recite:
Any chametz that may still be in my house, which I have not seen or removed, shall no longer be mine, but be as ownerless as the dust of the earth.

כָּל חֲמִירָא וַחֲמִיעָא דְּאִכָּא בִרְשׁוּתִי, דְּלָא חֲמִתֵּהּ וּדְלָא בְעַרְתֵּהּ וּדְלָא יְדַעְנָא לֵיהּ, לִבָּטֵל וְלֶהֱוֵי הֶפְקֵר כְּעַפְרָא דְאַרְעָא.

After burning the chametz the next morning, recite:
Any chametz that may still be in my house, whether I have seen it or not, whether I have removed it or not, shall no longer be mine, but be as ownerless as the dust of the earth.

כָּל חֲמִירָא וַחֲמִיעָא דְּאִכָּא בִרְשׁוּתִי, דַּחֲזִיתֵהּ וּדְלָא חֲזִיתֵהּ, דַּחֲמִיתֵהּ וּדְלָא חֲמִתֵּהּ, דְּבַעַרְתֵּהּ וּדְלָא בְעַרְתֵּהּ, לִבָּטֵל וְלֶהֱוֵי הֶפְקֵר כְּעַפְרָא דְאַרְעָא.

CANDLELIGHTING

BLESSED ARE YOU, Lord our God, King of the universe, who has sanctified us with your commandments, and commanded us to light the (Shabbat and the) Yom Tov lights.

Barukh atah Adonai, Eloheinu melekh ha-olam, asher kid'dishanu bemitzvotav vetzevanu lehadlik ner shel (Shabbat veshel) yom tov.

בָּרוּךְ אַתָּה יְיָ, אֱלֹהֵינוּ מֶלֶךְ הָעוֹלָם, אֲשֶׁר קִדְּשָׁנוּ בְּמִצְוֹתָיו וְצִוָּנוּ לְהַדְלִיק נֵר שֶׁל (שַׁבָּת וְשֶׁל) יוֹם טוֹב.

BLESSED ARE YOU, Lord our God, King of the universe, who has kept us in life, sustained us, and brought us to celebrate this festival.

Barukh atah Adonai, Eloheinu melekh ha-olam, sheheheyanu v'kiy'manu v'higiyanu la-z'man ha-zeh.

בָּרוּךְ אַתָּה יְיָ, אֱלֹהֵינוּ מֶלֶךְ הָעוֹלָם, שֶׁהֶחֱיָנוּ וְקִיְּמָנוּ וְהִגִּיעָנוּ לַזְּמַן הַזֶּה:

Hungary, 1947.

France, 1947.

Israel, 1955.

Romania, 1994.

ORDER *of the* PASSOVER SEDER

KADESH
Recite the Kiddush over wine.

קַדֵּשׁ.

URCHATZ
Wash the hands.

וּרְחַץ.

KARPAS
Eat a vegetable dipped in salt water.

כַּרְפַּס.

YAHATZ
Break the middle matzah.

יַחַץ.

MAGGID
Tell the story of Passover.

מַגִּיד.

RAHTZAH
Wash the hands.

רָחְצָה.

MOTZI MATZAH
Eat the matzah.

מוֹצִיא מַצָּה.

MAROR
Eat the bitter herbs.

מָרוֹר.

KOREKH
Eat the Hillel sandwich.

כּוֹרֵךְ.

SHULHAN OREKH
Enjoy the feast.

שֻׁלְחָן עוֹרֵךְ.

TZAFUN
Eat the Afikoman.

צָפוּן.

BAREKH
Recite the blessings after the meal.

בָּרֵךְ.

HALLEL
Recite the chapters of praise.

הַלֵּל.

NIRTZAH
Conclude the Seder.

נִרְצָה.

THE SEDER PLATE

ABOVE:

"THIS YEAR IN JERUSALEM"

In the weeks before the establishment of the State of Israel, the JDC produced this seder plate with the words "This Year in Jerusalem," a twist on the traditional prayer of "Next Year in Jerusalem." It was used in Foehrenwald and other Displaced Persons Camps in Germany by some of the 250,000 homeless Holocaust survivors whom the JDC cared for after World War II. The seder plate, now on display at the U.S. Holocaust Museum, was a note of hope and comfort in a turbulent time. *Germany, 1946.*

THE SEDER PLATE consists of five items. In the top left corner is the *Beitzah*, a hard boiled egg. In the bottom left corner is *Karpas*, which is either parsley, celery, lettuce, onion, or potato. The bottom right corner is the *Charoset*, a mixture of finely chopped apples, nuts, and cinnamon mixed with a little wine. In the top right corner is the *Zroa*, a roasted shankbone of lamb. In the very center of the plate is *Maror*, bitter herbs cut into small pieces, or grated fresh horseradish.

The seder plate is placed on the table in front of the leader. Other items on the seder table are: **three matzahs**, which should be placed separately in matzah covers, or folded separately in one or two large napkins; **wine**, with a full bottle on the table and a wine glass in front of each setting; **salt water**, with at least one dish available at the table; **cup of Elijah**, a large wine glass filled with wine and placed near the center of the table; **pillow** or cushion on the left arm of the leader's chair.

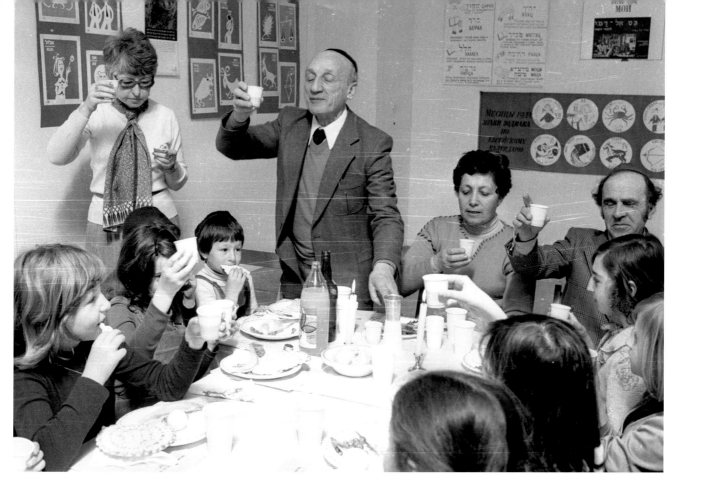

KADESH

קַדֵּשׁ

Raise the wine cup and recite the Kiddush.
On Friday evening, add the following paragraph recited standing:

THERE WAS EVENING and there was morning
the sixth day. The heavens and the earth and all
they contain were finished. On the seventh day,
God finished the work of creation and rested.
God blessed the seventh day and made it holy,
because on this day God completed all the work
of creation.

יוֹם הַשִּׁשִּׁי, וַיְכֻלּוּ הַשָּׁמַיִם
וְהָאָרֶץ וְכָל צְבָאָם:
וַיְכַל אֱלֹהִים בַּיּוֹם הַשְּׁבִיעִי, מְלַאכְתּוֹ
אֲשֶׁר עָשָׂה, וַיִּשְׁבֹּת בַּיּוֹם הַשְּׁבִיעִי,
מִכָּל מְלַאכְתּוֹ אֲשֶׁר עָשָׂה: וַיְבָרֶךְ אֱלֹהִים
אֶת-יוֹם הַשְּׁבִיעִי, וַיְקַדֵּשׁ אֹתוֹ, כִּי בוֹ
שָׁבַת מִכָּל-מְלַאכְתּוֹ, אֲשֶׁר בָּרָא
אֱלֹהִים לַעֲשׂוֹת:

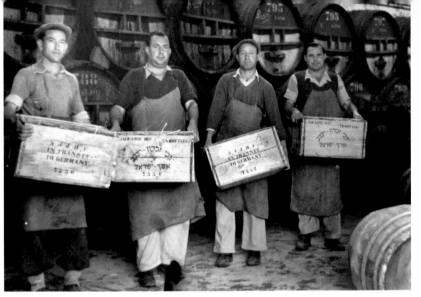

ABOVE:
Preparing cases of wine for shipment from Palestine to Displaced Persons (DP) camps in Europe in time for the Passover holiday, the first Festival of Freedom to be celebrated by many Holocaust survivors since their liberation. *Palestine, 1946.*

LEFT:
This elderly Jew from Yemen lifts his cup in blessing at the *MALBEN* home for the aged in Neve Haim. *Israel, 1960.*

OPPOSITE PAGE:
Nehemiah Maccabi, a teacher sent from Israel to work with Soviet Jewish émigrés in Italy, guides his students at a "dress rehearsal" for the seder, explaining the significance of each element and custom. *Italy, 1979.*

A PIOUS WOMAN approached the rabbi of the Russian city of Brisk with a strange question. She wanted to know if she could use milk instead of wine for the four cups traditionally drunk at the seder. "Milk is all I can afford," she explained apologetically. The rabbi responded by giving the woman 100 rubles, a handsome sum at the time. After the woman left, the rabbi's wife asked him, "but wine is only 10 rubles. Why did you give her so much?"

"If she wants to drink milk at the seder, it is obvious that she has no meat for the holiday," the rabbi said. "And since she was going to spend her last rubles on the four cups, she probably has no fish either. And perhaps no candles and no matzah. She needs far more than 10 rubles to make the seder."

The rabbi of Brisk was displaying what Rabbi Joseph Telushkin describes as "moral imagination," the kind of insight that recognizes needs beyond what is obvious. In order to be a truly moral people, we have to use our full intellectual efforts to see beyond the immediate need. No organization in the Jewish world has greater "moral imagination" than the JDC.

From its earliest days, JDC's mission has been to reach out to Jews in peril. When dealing with such life and death issues, wine might seem like a frivolous item. And yet, from its earliest days JDC has sent barrels upon barrels of wine to isolated and endangered Jews around the world.

Why is wine so significant? On one level, it is a rabbinic command. "A man is duty-bound to sell his clothes, or to borrow money, or to hire himself out to obtain wine for the four cups," the Mishna states. But on another level, wine is a comfort and a connection for Jews in peril. It ties them to their heritage and to the wider Jewish world.

This is not some luxury item. Listen to this testimony from Morris Wyszogrod, an artist who would survive the war and later design the JDC emblem. These are his memories of Passover 1942 in the Warsaw Ghetto as recounted in his book, *A Brush with Death: An Artist in the Death Camps.* "My mother had set the table just as she always did, with our special Pesach dishes, white porcelain plates with a floral border… My father, who sat at the head of the table, raised his glass of water and made a kiddush… He wanted so much to believe that the miracle of our people's deliverance from Egypt would occur for us, too."

It wasn't until after the war that the Passover wine began flowing again to Europe. In 1946, JDC shipped 75,000 bottles of wine, marked "Kosher for Passover," directly from pre-state Israel to Displaced Persons camps in the American and British zones of Germany, Austria and Italy. Refugees who escaped almost certain death were suddenly celebrating the holiday with a taste of freedom on their lips.

BLESSED ARE YOU, Lord our God, King of the universe, who creates the fruit of the vine.

Barukh atah Adonai, Eloheinu melekh ha-olam, borei p'ri ha-gefen.

BLESSED ARE YOU, Lord our God, King of the universe, who has has chosen us from every other nation and made us holy with commandments: who gave us (*Shabbat* for rest and) the festivals for rejoicing, including (this *Shabbat* and) this Festival of *Matzot*, the anniversary of our freedom, as a holy occasion reminding us of the Exodus from Egypt.
You chose us and made us holy by giving us (*Shabbat* and) the festivals.
Blessed are You, God, who makes (*Shabbat*,) Israel and the festivals holy.

בָּרוּךְ אַתָּה יְיָ, אֱלֹהֵינוּ מֶלֶךְ הָעוֹלָם,
בּוֹרֵא פְּרִי הַגָּפֶן:

בָּרוּךְ אַתָּה יְיָ, אֱלֹהֵינוּ מֶלֶךְ הָעוֹלָם,
אֲשֶׁר בָּחַר בָּנוּ מִכָּל
-עָם, וְרוֹמְמָנוּ מִכָּל לָשׁוֹן, וְקִדְּשָׁנוּ
בְּמִצְוֹתָיו, וַתִּתֶּן-לָנוּ יְיָ אֱלֹהֵינוּ
בְּאַהֲבָה (לשבת שַׁבָּתוֹת לִמְנוּחָה וּ)
מוֹעֲדִים לְשִׂמְחָה, חַגִּים וּזְמַנִּים לְשָׂשׂוֹן,
אֶת יוֹם (לשבת הַשַּׁבָּת הַזֶּה וְאֶת-יוֹם) חַג הַמַּצּוֹת
הַזֶּה, זְמַן חֵרוּתֵנוּ, (לשבת בְּאַהֲבָה,) מִקְרָא קֹדֶשׁ,
זֵכֶר לִיצִיאַת מִצְרָיִם. כִּי בָנוּ בָחַרְתָּ וְאוֹתָנוּ
קִדַּשְׁתָּ מִכָּל-הָעַמִּים. (לשבת וְשַׁבָּת) וּמוֹעֲדֵי
קָדְשֶׁךָ (לשבת בְּאַהֲבָה וּבְרָצוֹן) בְּשִׂמְחָה וּבְשָׂשׂוֹן
הִנְחַלְתָּנוּ: בָּרוּךְ אַתָּה יְיָ, מְקַדֵּשׁ
(לשבת הַשַּׁבָּת וְ)יִשְׂרָאֵל וְהַזְּמַנִּים:

On Saturday evening, recite the following:

BLESSED ARE YOU, Lord our God, King of the universe, who creates the radiances of fire.

בָּרוּךְ אַתָּה יְיָ, אֱלֹהֵינוּ מֶלֶךְ הָעוֹלָם,
בּוֹרֵא מְאוֹרֵי הָאֵשׁ:

BLESSED ARE YOU, Lord our God, King of the universe, who has made a difference between the holy and the ordinary, between light and darkness, between Israel and other nations, between the seventh day and the six days of the work week. You have made a difference between the holiness of Shabbat and the holiness of the festivals, and made Shabbat holier than the other days of the week. You have made us holy through these differences. Blessed are You, God, who makes differences in degrees of holiness.

בָּרוּךְ אַתָּה יְיָ, אֱלֹהֵינוּ מֶלֶךְ הָעוֹלָם,
הַמַּבְדִּיל בֵּין קֹדֶשׁ לְחֹל. בֵּין אוֹר
לְחֹשֶׁךְ, בֵּין יִשְׂרָאֵל לָעַמִּים, בֵּין יוֹם
הַשְּׁבִיעִי לְשֵׁשֶׁת יְמֵי הַמַּעֲשֶׂה. בֵּין קְדֻשַּׁת שַׁבָּת
לִקְדֻשַּׁת יוֹם טוֹב הִבְדַּלְתָּ. וְאֶת יוֹם הַשְּׁבִיעִי
מִשֵּׁשֶׁת יְמֵי הַמַּעֲשֶׂה קִדַּשְׁתָּ. הִבְדַּלְתָּ וְקִדַּשְׁתָּ
אֶת-עַמְּךָ יִשְׂרָאֵל בִּקְדֻשָּׁתֶךָ. בָּרוּךְ אַתָּה יְיָ,
הַמַּבְדִּיל בֵּין קֹדֶשׁ לְקֹדֶשׁ:

On every evening, conclude:

BLESSED ARE YOU, Lord our God, King of the universe, who has kept us in life, sustained us, and brought us to celebrate this festival.

Barukh atah Adonai, Eloheinu melekh ha-olam, sheheheyanu v'kiy'manu v'higiyanu la-z'man ha-zeh.

בָּרוּךְ אַתָּה יְיָ, אֱלֹהֵינוּ מֶלֶךְ הָעוֹלָם,
שֶׁהֶחֱיָנוּ וְקִיְּמָנוּ וְהִגִּיעָנוּ לַזְּמַן הַזֶּה:

Drink the first cup of wine while reclining to the left.

COMMUNAL PASSOVER SEDERS *have been organized by JDC in many places over the past half-century, including a city under siege (Sarajevo, 1994), but those that were held in the Soviet Union in the spring of 1990 were perhaps the most poignant. A product of creative interplay between lay leaders and professional staff, Operation Seder enabled over 10,000 Soviet Jews to publicly celebrate Passover in 1990, many for the very first time.*

In a triumph of complicated logistics executed in the midst of a disintegrating Soviet empire, locations were chosen and all of the requisite materials for a seder – including Russian-language Haggadot and seder plates – were shipped from Israel to cities as far apart as Kiev and Astrakhan, Riga and Tashkent.

The specially trained couples sent from Israel to guide people though the age-old rituals were as overwhelmed by the experience as the participants – as is evident in these excerpts from their reports:

VITEBSK:

"For us, the Israeli delegation, it was the experience of our lives. We had a part in bringing happiness to these Jews, and pride in being Jewish, which had been lost to them for so many years."

ODESSA:

"Already on the eve of the holiday, Jews were hurrying to the synagogue to see the miracle of the seder being prepared. After so many years of fear and estrangement … people climbed onto the windowsills and crowded into the hallways to be part of the happening, to sing together, 'Next Year in Jerusalem.' I explained the sheheheyanu blessing — that we lived to reach this day. And when the children sang the Passover songs … and the large congregation joined them, we understood that this was a song impossible to stop."

MOSCOW:

"I never saw such a sea of people who gathered in the plaza outside the synagogue trying to get in for the seder. It was like a pilgrimage to a holy site…."

LVOV:

"I, a native-born Israeli, saw a nation rise from its dust and ashes and I saw that the Jewish nation lives."

GRODNO:

"It was a world of Jewish identity awakening. Only when I was there did I understand fully why this JDC operation was held on Passover, the holiday of our freedom."

Photo: JDC.

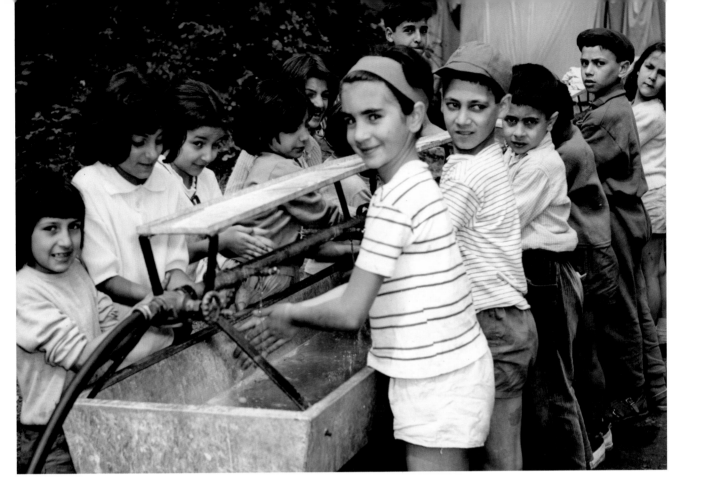

URCHATZ

Wash hands without a blessing.

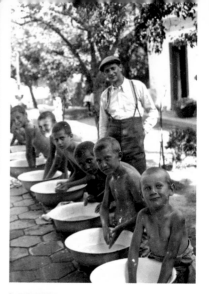

BOTTOM LEFT:
Washing up at a JDC-supported kindergarten in Tehran. *Iran, 1946.*
TOP LEFT:
Ritual handwashing before a meal at Agro-Joint Colony No. 36 in the Eupatoria District. *Soviet Union, 1929.*
ABOVE:
The children's center at Stavanger, site of a Norwegian government resettlement program for former TB patients and their families brought from Germany by JDC. *Norway, 1952.* Photo: Jerome Silberstein
TOP RIGHT:
Morning clean-up at a summer camp for Jewish children in Nagymaros. *Hungary, 1935.*
BOTTOM RIGHT:
A young North African émigré assisted by JDC. *France, 1959.*
OPPOSITE PAGE:
Campers washing up in Laversine, at one of 71 summer camps organized that year for Jewish youngsters from Algeria and elsewhere. *France, 1963.*

WATER IS A CONSTANT THEME in the Haggadah. At this point in the seder, we wash our hands without a blessing, and we'll do it again later with a blessing. Sometimes water is pleasure and sometimes it is ritual; and sometimes it's both.

But this is only the beginning of water imagery at the seder. We have salt water on the table to remind us of the tears the Israelites shed in Egyptian bondage. We recall the story of the infant boys thrown into the Nile, the plague of water turning into blood, the splitting of the Red Sea and the miracle of Miriam's well.

Getting water to those who need it has been part of JDC's mission from its early days to today. When the 2004 tsunami in the Indian Ocean caused death and destruction in 11 countries, JDC raised over $19 million for relief and rehabilitation efforts, and getting fresh drinking water to survivors was part of its initial emergency aid. It was one of the Joint's numerous non-sectarian efforts.

Some of the most moving images in JDC's history have been when refugees have been connected with water. Basins and buckets and water spouts and drinking fountains meant health and refreshment and survival.

One can almost hear the squeals of joy and feel the sighs of relief when viewing pictures from a resettlement program in Norway; summer camps in Hungary and France; a well in Ethiopia; a kindergarten in Tehran. You can feel the water on your face.

In all these images, it is clear that water sustains life, cleanses, refreshes and brings joy. Is it any wonder that one of the most popular Israeli dances, *Mayim*, takes its words from the prophet Isaiah, who wrote, "With joy shall you draw water from the wells of deliverance."

JDC has provided both water and deliverance.

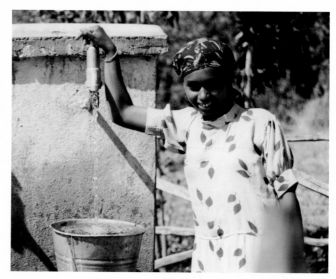

ABOVE:
A JDC nonsectarian water project in Gondar Province, then home to large numbers of Jews. *Ethiopia, 1988.* Photo: Rick Hodes.

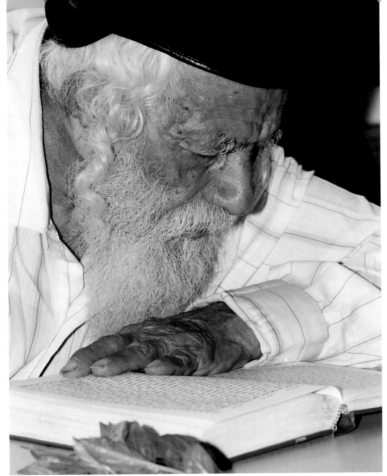
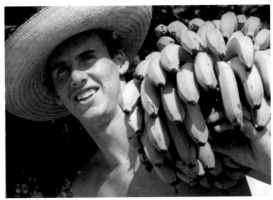

KARPAS

כַּרְפַּס

Dip a vegetable (parsley, celery, lettuce or potato) in salt water and recite:

BLESSED ARE YOU, Lord our God, King of the universe, who creates the fruit of the earth.

Barukh atah Adonai, Eloheinu melekh ha-olam, borei p'ri ha-adamah.

Eat the vegetable dipped in salt water.

בָּרוּךְ אַתָּה יְיָ, אֱלֹהֵינוּ מֶלֶךְ הָעוֹלָם, בּוֹרֵא פְּרִי הָאֲדָמָה:

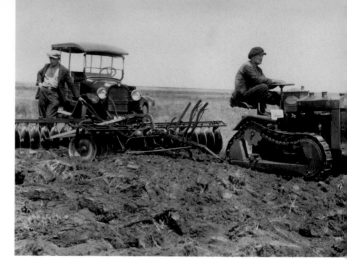

A GENTLEMAN *living in the central Russian town of Penza wrote to thank JDC for the help he was receiving from Hesed Mordechai, one of the network of welfare centers established to aid the former Soviet Union's neediest elderly Jews. Describing himself as "a former resident of your agricultural colony in the Crimea," he emphasized that this was not the first time he was benefiting from the Joint's assistance:*

"I have known about JDC since my early childhood. You helped my parents with credit to build a house, and to buy agricultural tools and cattle. Today I am 77, and I see how you are addressing the pressing needs of aged Jews suffering from loneliness and neglect. Your support … is absolutely in keeping with the traditional Joint philosophy. I am privileged (again) to witness it."

ABOVE:
Two settlers with Agro-Joint tractor in the field. *Soviet Ukraine, c.1925.* Photo: Max Belenky
OPPOSITE PAGE, LEFT:
Israel, circa 1980.
OPPOSITE PAGE, FAR RIGHT TOP:
Bringing in the banana crop at the agricultural settlement in Sosúa, founded as a haven for Nazi-era Jewish refugees. *Dominican Republic, 1940s.* Photo: Dr. Kurt Schnitzer
OPPOSITE PAGE, FAR RIGHT BOTTOM:
These young members of an Athens *hachsharah* (training) group are as eager as their parents to learn how to be *halutzim* (pioneer farmers) in Israel. *Greece, 1947.* Photo: Al Taylor

CONTRASTING IMAGES OF SLAVERY AND FREEDOM are themes that we encounter throughout the Haggadah. In Karpas, we bring these two themes together when we dip a green vegetable, symbolizing spring, into salt water, a reminder of the tears shed in Egyptian bondage.

For a people oppressed, there is perhaps no greater symbol of hope than a sprig of green. It is what the dove brings back to Noah after the flood. It means that there are signs of life and a future. At numerous points in modern history, it seemed that Jews needed to prepare for an agricultural future.

When the Soviet Union was formed, Jews were barred from many crafts and businesses that had sustained them under czarist rule. Many had to turn instead to the land to make their living. In 1924, the Joint entered into an agreement with the Soviet government to help redirect Jewish economic activity. The program, which became known as Agro-Joint, set aside vast areas of land in the Pale of Settlement for Jews to cultivate. Between 1924 and 1938, Agro-Joint helped settle some 70,000 Jews in agricultural colonies in Crimea and Ukraine.

With the rise of Hitler in Germany, there was an urgent need to retrain Jews who lost their jobs through the dreadful Nuremberg laws. Most important, these new skills would also make them more attractive for immigration to other countries. Between 1933 and 1939, training groups, known as *hachsharot*, were set up in Germany and

other countries that came under the sway of Nazi power. These groups emphasized agricultural training that would be useful if the refugees, against great odds, made their way to Palestine.

One of the few countries hospitable to Jews during the war was the Caribbean island nation of the Dominican Republic. The Dominican government issued over a thousand visas for European Jews, although only several hundred were able to come. Those who did settled in an agricultural community in the seacoast town of Sosua, where they put their newly learned agricultural skills to use.

After the *Shoah*, Zionist agricultural training camps were reestablished in Germany as well as in Holland, Greece, Morocco, Czechoslovakia, Italy and France. One such camp in Germany was founded by 20 young survivors of the notorious concentration camp at Buchenwald and was quite remarkably called "Kibbutz Buchenwald." The members immigrated to Palestine in 1946 and, together with many others, used their skills to create new lives for themselves and to rebuild the Jewish homeland.

While today Israel excels as a center for commerce, high tech and tourism, in the early days of the state, the great economic hope was agriculture. The dominant images of the day were of Jewish refugees picking oranges and tomatoes on the *kibbutzim* and farms of the young state. These early agricultural efforts transformed lives and gave hope for the future.

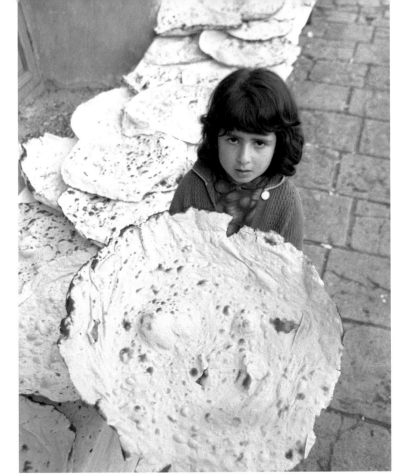

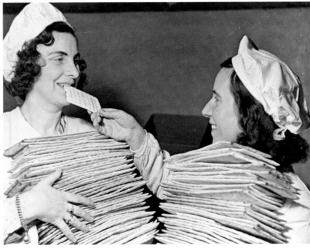

ABOVE:
Bakery workers in Berlin worked two shifts a day from Feburary on to produce some 25 tons of Passover matzah in 1946, the first to be baked in that city in 10 years. Together with other kosher for Passover items shipped by JDC, it made "this first free Passover a *real* Passover." *Germany, 1946.*

LEFT:
It may be difficult to carry, but this matzah was made the traditional way by this nursery school student in Tehran. *Iran, 1964.*

YAHATZ

יַחַץ

The leader breaks the middle matzah of the three matzot, wrapping the larger half in a napkin for later use as the Afikoman and placing the smaller part on top of the seder plate.

THE IMPORTANCE OF MATZAH *in the lives of our fellow Jews is illustrated by the following story from Asher Ostrin, director of JDC's programs in the former Soviet Union. Describing a day spent some years ago distributing food packages the week before Passover to needy elderly Jews, he focused on Clara, whose welcoming smile had turned to tears when she saw a kilo of matzah amid the standard package items.*

She led him into the kitchen, where each of her communal apartment's residents had a little cubby in which to store food. Clara's was empty except for a tiny package that was clearly of tremendous value to her. "Slowly she took apart the paper wrapping; below was another wrapping that looked like it was made of red velvet," wrote Ostrin. "She slowly unwrapped the velvet, and as she peeled it away she revealed — a piece of matzah. The tears became more intense, and so did my puzzlement, until Clara explained.

'I have not been able to observe Jewish tradition for many years,' she said, 'but in my parents' home, I remember that Passover was always a special time. I resolved years ago that if, under the Communist system here, I could do nothing else, I would always eat matzah on Passover, to remember who I am.'

'For the last nine years,' she continued, 'I have not been able to leave this apartment. And I no longer know the exact date of Passover. But I know that it is in the spring. So each spring I take this piece of matzah and put in on my table for a week's time to remind me. Even if I don't have enough to eat, it will be here to remind me.'

'And now, you angels from Joint have come and brought me something I could never have dreamed of. I can be a part of my people once again,' Clara concluded with a smile."

PROBABLY NOTHING SYMBOLIZES the Passover festival as much as matzah. Of course, there's wine at the seder, but we drink wine all year round. Of course, there are questions, but we ask questions all year round. And of course there's food. But what else is new?

Matzah is the bread of affliction, reminding us of the chaos of the Exodus, when our ancestors didn't even have the time to let the dough rise. But matzah also assures us that liberation can come in an instant, sometimes when we are least prepared for it.

The very first factories that Jews opened in Germany after the Nazis' defeat were matzah bakeries. From 1946, we have a picture of two women in bakers' hats, their arms filled with square sheets of matzah, happily sampling their wares. Their efforts were part of the campaign to distribute over two million pounds of matzah to Europe's Jews for Passover 1946.

Matzah comes in different shapes and sizes. In Iran's proud Jewish community, they made it big. A 1964 photo from Tehran shows a little girl dwarfed by the matzah in her hands.

Matzah took on special symbolism for Jews during the Soviet era. In times of severe repression, Jews clandestinely baked matzahs in their own kitchens, with parents passing the tradition on to their children. In better times, matzah was baked and sold publicly in the main synagogue in Moscow. Jews would line up for hours to buy some for the holiday, but they sometimes risked losing their jobs or other sanctions for being seen buying matzah.

Outside the Soviet Union, it also became a symbol. For many years, Jews at seders around the world added a fourth matzah to the traditional three to keep the plight of Soviet Jews at the front and center of their consciousness.

Rabbi Menachem Hacohen, a member of the Israeli Knesset during the dark days of Soviet rule, met with refuseniks during his visits to the Soviet Union in the 1970s and '80s. One Passover he brought a cloth matzah cover with him and had the refuseniks sign it, some in Russian and some in Hebrew. Hacohen kept the matzah cover until each of the signers made his way to Israel. Yuli Edelstein was among them.

Mikhail Chlenov, president of the Va'ad, the Federation of Jewish Organizations in Russia, even went as far as to say that Judaism survived the Soviet era because of matzah. It gave Soviet Jews both spiritual sustenance and hope.

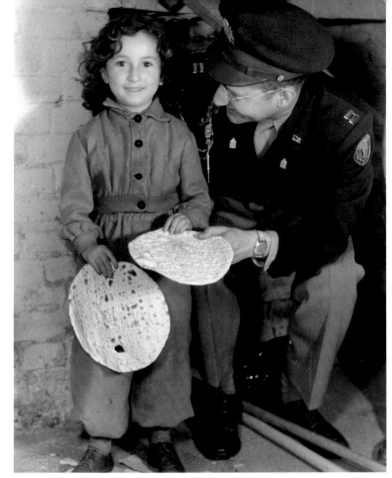

ABOVE:

By 1995, almost the entire demand for Passover matzah in the former Soviet Union was being met by local production, obviating the need for large shipments from the West. JDC facilitated this development, supporting an additional production line in this matzah factory in Kiev, for example, as well as the building or expansion of facilities in Moscow, St. Petersburg, Samara, Tbilisi, and Baku. *Ukraine, 1994.* Photo: Kenneth Rubens

LEFT:

Shmurah matzah was supplied to Orthodox Jews in the DP camps, prepared from specially selected wheat and baked in the prescribed manner. The finished product is enjoyed by the American Jewish chaplain for Berlin, Capt. J. Robbins, and a delighted young resident of the Berlin-Mariendorf DP camp. *Germany, 1946.*

Photo: Alois Bankhardt, Jewish Museum of Berlin, gift of Fred Kranz.

MAGGID

מַגִּיד

Lift the seder plate with the broken middle matzah on it and recite:

THIS IS THE BREAD OF AFFLICTION that our ancestors ate in the land of Egypt. Let all who are hungry come and eat with us.

LET ALL WHO ARE NEEDY come and observe Pesach with us. Now we are here; next year may we be in the land of Israel. Now we are slaves; next year may we all be free.

Put down the seder plate, cover the matzah, and fill the second cup of wine.

הָא לַחְמָא עַנְיָא דִי אֲכָלוּ אַבְהָתָנָא
בְּאַרְעָא דְמִצְרָיִם. כָּל דִכְפִין יֵיתֵי
וְיֵכוֹל, כָּל דִצְרִיךְ יֵיתֵי וְיִפְסַח. הָשַׁתָּא
הָכָא, לְשָׁנָה הַבָּאָה בְּאַרְעָא דְיִשְׂרָאֵל.
הָשַׁתָּא עַבְדֵי, לְשָׁנָה הַבָּאָה בְּנֵי חוֹרִין:

EFFORTS TO HELP JEWS *in need have taken many forms. The package program maintained throughout the Cold War decades was one of the most inventive. Benefiting as it did from the hands-on involvement of JDC lay leaders, it succeeded in channeling aid to those living in countries that were politically beyond reach. It included an indirect, delicate lifeline to Jews in the Soviet Union — which aided the refuseniks who had lost their livelihoods after applying to leave for Israel and other Jews at risk. Witness how much such assistance meant to each recipient:*

A STORY TOLD AT A COMMUNITY GATHERING IN THE U.S. IN THE EARLY 1980s:

"It was after the war in Budapest, liberated by the Red Army, but with no food and no place to turn. Then my mother got a notice: a package at the post office. We knew these packages from the Joint, with things everyone wanted. You could sell them and buy food for your children. And always something special inside— small and valuable, like a pen—to give the customs man so he'd let you take the rest home, so the children could eat and live...."

A LETTER FROM THE SOVIET UNION, DATED SIMPLY 1963:

"My dear, distant, and yet near friend! I am writing to you from sunny Tbilisi in faraway Georgia. I have already several times received parcels from you and until now I do not know whom I have to thank. You know my name...but who are you, how are we related? Who is your family?"

A LETTER FROM THE SOVIET UNION, DATED VILNA, JANUARY 22, 1964:

"This letter is being written by a woman I am 82 years old and I am all alone. I have lost my entire family. I can no longer work. I receive for my son who fell at the front a pension of 16 rubles a month. It is very little. But thanks be to God, I receive every year a present from you, so I have for Pesach and little bits here and there during the whole year.

Dear Jews, I request you please do not forget me... I wish you good health and a good, kosher and healthy Pesach."

ABOVE:
Treasured for the Hebrew lettering so rarely seen in this region during the Soviet era, this wrapper from a box of matzah received in 1970 in the Ukrainian *shtetl* of Bershad was found 35 years later, carefully tucked away among the community's few books.

ABOVE:
In the years immediately following World War II, JDC became known as the "world's largest purchaser of Passover products," and to this day it continues to supply Passover essentials to Jewish communities near and far. The Israeli matzah pictured here is being prepared for shipment to a variety of destinations. *Israel, 1979.*

MAH NISHTANAH

The youngest present asks the Four Questions:

HOW DIFFERENT this night is from all other nights!

1. On all other nights we eat either hametz or matzah; why do we eat only matzah tonight?

2. On all other nights we eat all kinds of vegetables; why do we eat bitter herbs tonight?

3. On all other nights we do not dip our food even once; why do we dip our food twice tonight?

4. On all other nights we eat either sitting up straight or reclining; why do we all recline tonight?

מַה נִּשְׁתַּנָּה הַלַּיְלָה הַזֶּה מִכָּל הַלֵּילוֹת?

שֶׁבְּכָל הַלֵּילוֹת אָנוּ אוֹכְלִין חָמֵץ וּמַצָּה, הַלַּיְלָה הַזֶּה כֻּלּוֹ מַצָּה:

שֶׁבְּכָל הַלֵּילוֹת אָנוּ אוֹכְלִין שְׁאָר יְרָקוֹת, הַלַּיְלָה הַזֶּה מָרוֹר:

שֶׁבְּכָל הַלֵּילוֹת אֵין אָנוּ מַטְבִּילִין אֲפִילוּ פַּעַם אֶחָת. הַלַּיְלָה הַזֶּה שְׁתֵּי פְעָמִים:

שֶׁבְּכָל הַלֵּילוֹת אָנוּ אוֹכְלִין בֵּין יוֹשְׁבִין וּבֵין מְסֻבִּין, הַלַּיְלָה הַזֶּה כֻּלָּנוּ מְסֻבִּין:

ABOVE:
Children have a place of their own at this communal Passover seder in Cuba, where the resurgence of this remarkable Jewish community has benefited from JDC's support since 1991.
Cuba, 2008.

OPPOSITE PAGE:
These young Soviet émigrés formed a choir to sing at the community seder in Ostia, and they are practicing for their debut.
Italy, 1979.

THROUGHOUT *the former Soviet bloc, the generations have been drawn together by the excitement of Jewish renewal and rediscovery. But the paths of Jewish learning have not always followed the traditional pattern. Jewish kindergarten and Sunday school programs led to special classes for inquiring parents, and camps for Jewish youngsters evolved into year-round family-centered activities and study programs. Witness the following account from Jenya, a law student who became an active participant in Hillel leadership activities. She dates her "Jewish awakening" to her participation in a Passover seder held at the Kiev Hillel:*

"I returned home from the seder glowing with pride," she recalled, and her enthusiasm was catching. *"My parents and grandparents had forgotten all the rituals,"* she explained, so her father suggested that she lead the seder for them the next night. And so the day after her first-ever celebration of the Exodus, Jenya led another celebration for her family, arousing memories of experiences they had not had for decades. Her grandfather asked the Four Questions.

THIS IS WHERE THE CHILDREN of the seder step forward for a starring role. They ask the Four Questions. This is a tradition that goes back to the very first seders, as recorded in the Talmud. The children ask, the Talmud instructs. But what if there are no children present? If there are no children, it instructs, the wife should ask. If there is no wife, a friend should ask. And if there is no friend, the person conducting the seder should ask himself.

Why are these questions so important? Because the seder is not a lecture or a liturgy. It is a conversation. And nothing gets a conversation going like questions.

"Why is this night different from all other nights?"

The question was especially poignant for Jews in the late 1970s who had just left the Soviet Union and found themselves in transmigration communities in Austria and Italy, a necessary step before going on to new lives in Israel and the United States.

For many of these Jews, it was the first seder they could celebrate free from fear. Pictured here is a group of Russian boys practicing the Four Questions for a community seder in Italy in 1979. On the board behind them are the words in Hebrew.

The year 1979 was a peak year for Soviet Jewish emigration. More than 51,000 Jews were allowed to leave, nearly twice as many as the year before – or the year after. It was a dream come true for individuals and families who had been trying to leave for years if not decades.

It was also a dream come true for the leaders of the Soviet Jewry movement who had worked so hard, publicly and privately, to get Jews released. They even employed the language of the Exodus in their rallies and public statements. "Let my people go," they pleaded.

The Passover of 1979 was indeed a chance to ask, "Why is this night different from all other nights?"

AVADIM HAYINU

Uncover the matzah and recite:

WE WERE SLAVES to Pharaoh in Egypt, but God
freed us with a strong hand and an outstretched arm.
If God had not freed us, then we and our children and
our children's children would still be slaves to Pharaoh in
Egypt. Therefore, even if we were all wise, understanding
and learned in the Torah, we would still have to retell
the story of our Exodus from Egypt, and the more one
describes the Exodus from Egypt, the better.

עֲבָדִים הָיִינוּ לְפַרְעֹה בְּמִצְרָיִם,
וַיּוֹצִיאֵנוּ יְיָ אֱלֹהֵינוּ
מִשָּׁם, בְּיָד חֲזָקָה וּבִזְרֹעַ נְטוּיָה. וְאִלּוּ
לֹא הוֹצִיא הַקָּדוֹשׁ בָּרוּךְ הוּא אֶת־
אֲבוֹתֵינוּ מִמִּצְרַיִם, הֲרֵי אָנוּ וּבָנֵינוּ וּבְנֵי
בָנֵינוּ, מְשֻׁעְבָּדִים הָיִינוּ לְפַרְעֹה בְּמִצְרָיִם.
וַאֲפִילוּ כֻּלָּנוּ חֲכָמִים. כֻּלָּנוּ נְבוֹנִים,
כֻּלָּנוּ זְקֵנִים, כֻּלָּנוּ יוֹדְעִים אֶת־הַתּוֹרָה,
מִצְוָה עָלֵינוּ לְסַפֵּר בִּיצִיאַת מִצְרָיִם.
וְכָל הַמַּרְבֶּה לְסַפֵּר בִּיצִיאַת מִצְרַיִם,
הֲרֵי זֶה מְשֻׁבָּח:

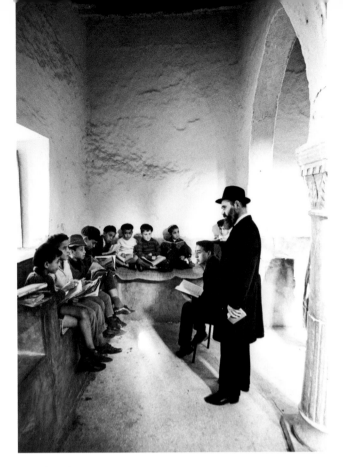

LEFT:
Rabbi Nissim Pinson (z"l), a pioneering figure in Jewish education in Tunisia, hears some young yeshiva students recite their lessons. *Tunisia, 1967.*

OPPOSITE PAGE, LEFT:
This 1948 Haggadah—published by and for the residents of the DP camps—was presented by the Joint with "the blessings of the Festival of Freedom." Its cover illustration expresses the hope of its creators, on the eve of Israel's birth, that new lives in the Jewish homeland would soon be theirs.

OPPOSITE PAGE, RIGHT:
The publication, "with the aid of the U.S. Army and the Joint," on German soil of what came to be known as the "DP Talmud" was considered by many survivors to be the ultimate symbol of the indestructibility of the Jewish people. The drawings on the set's title pages rise from the darkness of a Nazi slave labor camp to the sunlight of the Promised Land, following the words of the Hebrew inscription: "From slavery to redemption, from darkness to a great light."

THE FOUR QUESTIONS having been asked, the children deserve answers.

In some ways the rest of the seder is one big answer. The children want to know why we are gathered here and we begin our answer with a history lesson: Avadim Hayinu, "We were slaves to Pharaoh in Egypt, but God freed us with a strong hand and an outstretched arm."

Education was part of JDC's relief and rescue efforts from its very early days. As early as 1916, the JDC made grants to rabbis and their yeshiva students from Europe to live and study in Jerusalem. In 1921, the Joint formed a special committee charged with nurturing culture and religion. The first chair of the committee was Cyrus Adler, the great Semitic scholar who would later become chancellor of the Jewish Theological Seminary. Adler made a strong argument for elevating the role of education. "If you back up the spiritual side of man," he said, "you give him the power and the courage to look after his physical needs."

As a matter of policy, JDC is non-denominational. The array of educational programs it has supported over the years has ranged from vocational and agricultural training to rabbinical academies to secular Yiddish and high-tech institutes.

One of the hallmarks of Jewish education is that it is done best in group settings. "Two scholars sharpen one another," the Talmud asserts. This method of study is known as *havruta*, which derives from the same root as the Hebrew word *haver* or friend. As is clear from the accompanying pictures, learning is a social and communal activity as well as an intellectual one. Whether gathered around a teacher in Tunisia, a book in Morocco or a computer in Lithuania, learning is better in groups.

In the years after World War II, other forms of education were sometimes necessary. Diseases ran through many North African communities and parents needed to know both how to prevent them and how to identify symptoms.

In other contexts, music, theater and arts programs were most needed. After the collapse of Communism, for example, it became clear that many Jews were not opting for emigration but were going to stay in the countries of their birth. The JDC kept those Jews connected to their heritage through a variety of cultural programs. Beginning in the early 1990s, JDC supported Hillel centers, training for cantors, and music, dance and arts programs.

FIVE RABBIS – Rabbi Eliezer, Rabbi Yehoshua, Rabbi Elazar ben Azariah, Rabbi Akiva and Rabbi Tarfon – once spent the entire seder night in B'nei Brak, talking about the Exodus from Egypt, until their students came at dawn to say, "Masters, it is time to recite the morning *Shema*!"

מַעֲשֶׂה בְּרַבִּי אֱלִיעֶזֶר, וְרַבִּי יְהוֹשֻׁעַ, וְרַבִּי אֶלְעָזָר בֶּן־עֲזַרְיָה, וְרַבִּי עֲקִיבָא, וְרַבִּי טַרְפוֹן, שֶׁהָיוּ מְסֻבִּין בִּבְנֵי־בְרַק, וְהָיוּ מְסַפְּרִים בִּיצִיאַת מִצְרַיִם. כָּל־אוֹתוֹ הַלַּיְלָה, עַד שֶׁבָּאוּ תַלְמִידֵיהֶם וְאָמְרוּ לָהֶם: רַבּוֹתֵינוּ, הִגִּיעַ זְמַן קְרִיאַת שְׁמַע, שֶׁל שַׁחֲרִית:

RABBI ELAZAR BEN AZARIAH once said, "I am nearly seventy years old, but I was not convinced that the Exodus from Egypt should be mentioned every night in the *Shema* until Ben Zoma explained it to me through the Biblical verse, *that you may remember the day of your Exodus from Egypt all the days of your life. The days of your life* means only during the day; *all the days of your life* means the night as well. The Sages however explain that *the days of your life* means in this world; *all the days of your life* includes the time of the Messiah.

אָמַר רַבִּי אֶלְעָזָר בֶּן־עֲזַרְיָה. הֲרֵי אֲנִי כְּבֶן שִׁבְעִים שָׁנָה, וְלֹא זָכִיתִי שֶׁתֵּאָמֵר יְצִיאַת מִצְרַיִם בַּלֵּילוֹת. עַד שֶׁדְּרָשָׁהּ בֶּן זוֹמָא. שֶׁנֶּאֱמַר: לְמַעַן תִּזְכֹּר, אֶת יוֹם צֵאתְךָ מֵאֶרֶץ מִצְרַיִם. כֹּל יְמֵי חַיֶּיךָ. יְמֵי חַיֶּיךָ הַיָּמִים. כֹּל יְמֵי חַיֶּיךָ הַלֵּילוֹת. וַחֲכָמִים אוֹמְרִים: יְמֵי חַיֶּיךָ הָעוֹלָם הַזֶּה. כֹּל יְמֵי חַיֶּיךָ לְהָבִיא לִימוֹת הַמָּשִׁיחַ:

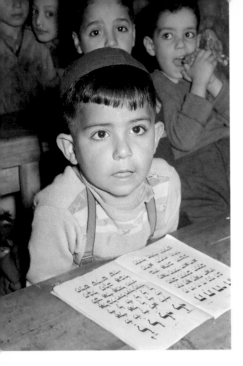

ABOVE:
The start of the school year in Vilnius brought a new world of computer-assisted Jewish learning to these delighted youngsters. *Lithuania, 1996.* Photo: Roy Mittelman

LEFT:
A little help from a friend makes studying easier at this yeshiva in Casablanca, where the Jewish schools have always been a focal point of community life. *Morocco, 1966.*

BELOW:
Students find learning Hebrew easier with their new Russian-Hebrew dictionaries. *Former Soviet Union, mid-1990s.*
Photo: Roy Mittelman

OPPOSITE PAGE:
Students and teachers consult the texts in the library of the Etz HaimYeshiva in Jerusalem, one of the country's oldest *yeshivot*.
Israel, 1950s.

TOP:
This eager young student is learning his Hebrew letters at a Jewish school in Marrakesh. *Morocco, 1955.*

ABOVE:
Yiddish was the language of instruction at this Agro-Joint school in the Crimea. *Soviet Russia, 1925.*

FOUR CHILDREN

BLESSED IS GOD, who is everywhere! Blessed is God! Blessed is God who gave Israel the Torah! Blessed is God! The Torah refers to four types of children: one who is wise, one who is wicked, one who is simple, and one who does not know how to ask a question.

What does the WISE CHILD ask?
"What are all the laws which God has commanded you?" (cf. Deuteronomy 6:20).
You should answer by explaining all the rules of Pesach, from beginning to end.

What does the WICKED CHILD ask?
"What does this ceremony mean to *you*?" (cf. Exodus 12:26). Since he says "to *you*" instead of "to *me*," he does not see himself as part of the Jewish people. You should scold him by saying, "This is because of what God did for *me* when I went free from Egypt" (cf. Exodus 13:8); "For *me*," not "for *you*" – Had you been there, you would not have been freed from slavery.

What does the SIMPLE CHILD ask?
"What is this?" You should answer, "With a strong hand, God freed us from slavery in Egypt" (cf. Exodus 13:14).

As for the CHILD WHO DOES NOT KNOW how to ask a question, you should open the discussion, as the Torah says: "You shall explain to your child on that day, "This is because of what God did for me when I went free from Egypt" (cf. Exodus 13:8).

YOU MIGHT THINK that the seder should be held on the first of Nisan. The Torah therefore teaches us, "on that day" (Exodus 13:8), that is, on the fifteenth (the first night of Pesach). You might think that "on that day" means that the seder should be held during the day. The Torah therefore teaches us, "because of this" (Exodus 13:8); "because of this" means when matzah and bitter herbs are set upon the seder plate at nightfall.

בָּרוּךְ הַמָּקוֹם. בָּרוּךְ הוּא. בָּרוּךְ שֶׁנָּתַן תּוֹרָה לְעַמּוֹ יִשְׂרָאֵל. בָּרוּךְ הוּא. כְּנֶגֶד אַרְבָּעָה בָנִים דִּבְּרָה תוֹרָה. אֶחָד חָכָם, וְאֶחָד רָשָׁע, וְאֶחָד תָּם, וְאֶחָד שֶׁאֵינוֹ יוֹדֵעַ לִשְׁאוֹל:

חָכָם מַה הוּא אוֹמֵר? מָה הָעֵדֹת וְהַחֻקִּים וְהַמִּשְׁפָּטִים, אֲשֶׁר צִוָּה יְיָ אֱלֹהֵינוּ אֶתְכֶם? וְאַף אַתָּה אֱמָר־לוֹ כְּהִלְכוֹת הַפֶּסַח: אֵין מַפְטִירִין אַחַר הַפֶּסַח אֲפִיקוֹמָן:

רָשָׁע מַה הוּא אוֹמֵר? מָה הָעֲבֹדָה הַזֹּאת לָכֶם? לָכֶם וְלֹא לוֹ. וּלְפִי שֶׁהוֹצִיא אֶת־עַצְמוֹ מִן הַכְּלָל. כָּפַר בְּעִקָּר. וְאַף אַתָּה הַקְהֵה אֶת־שִׁנָּיו, וֶאֱמָר־לוֹ: בַּעֲבוּר זֶה, עָשָׂה יְיָ לִי, בְּצֵאתִי מִמִּצְרָיִם. לִי וְלֹא־לוֹ. אִלּוּ הָיָה שָׁם, לֹא הָיָה נִגְאָל:

תָּם מַה הוּא אוֹמֵר? מַה זֹּאת? וְאָמַרְתָּ אֵלָיו: בְּחֹזֶק יָד הוֹצִיאָנוּ יְיָ מִמִּצְרַיִם מִבֵּית עֲבָדִים:

וְשֶׁאֵינוֹ יוֹדֵעַ לִשְׁאוֹל, אַתְּ פְּתַח לוֹ, שֶׁנֶּאֱמַר: וְהִגַּדְתָּ לְבִנְךָ, בַּיּוֹם הַהוּא לֵאמֹר: בַּעֲבוּר זֶה עָשָׂה יְיָ לִי, בְּצֵאתִי מִמִּצְרָיִם:

יָכוֹל מֵרֹאשׁ חֹדֶשׁ. תַּלְמוּד לוֹמַר בַּיּוֹם הַהוּא. אִי בַּיּוֹם הַהוּא, יָכוֹל מִבְּעוֹד יוֹם, תַּלְמוּד לוֹמַר, בַּעֲבוּר זֶה. בַּעֲבוּר זֶה לֹא אָמַרְתִּי, אֶלָּא בְּשָׁעָה שֶׁיֵּשׁ מַצָּה וּמָרוֹר מֻנָּחִים לְפָנֶיךָ:

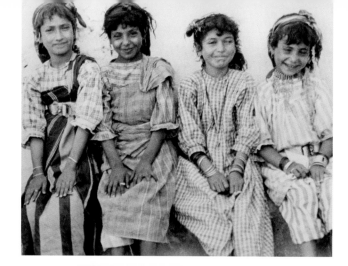

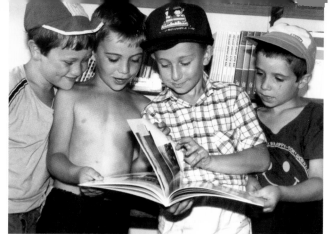

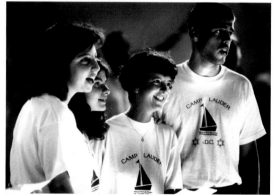

TOP LEFT:
This friendly foursome posed for a visitor as the search for havens for European refugees brought North African Jewish communities like theirs into sharper focus. *Tunisia, 1943.*
LEFT:
A choir performs at the Ronald S. Lauder Foundation/JDC International Summer Camp at Szarvas, where each year 2,000 young Jews share a unique Jewish learning experience. *Hungary, 1996.* Photo: Roy Mittelman
ABOVE:
New land, new library, new books: these newest Israelis have found something of interest to share. *Israel, 1996.*
BELOW:
Hot soup helps provide a nourishing lunch for these four young schoolgirls. *Tunisia, 1948.*

MANY ILLUSTRATED HAGGADOT attempt to depict the wise, the wicked, the simple and the timid child with everything from beards and books to lollipops and skateboards to guns and swords. Truth is, we don't really know who is good and who is bad. And a careful reading of the text demonstrates that there is little difference between the questions they pose.

"What are the laws that God commanded you?" the wise one begins.

"What does this ceremony mean to you?" the wicked starts.

"What is this?" the simple one begins.

Aren't they all just searching for knowledge? And even the timid one, who can't quite get out a question, seems to have our full attention.

What is clear from this part of the seder is that it is not so important what the four children ask but that they have come here to the seder to learn and listen. The wicked, the wise, the simple and the timid, they are all welcome. After all, we often do not know who is who. Looks and words can be deceiving. And people are not static. A child in one category one year may shift to the next the following year, or even the following day.

On this page we present pictures of groups of Jewish youth in Tunisia, Hungary and Israel. They're just children. Love them for who they are.

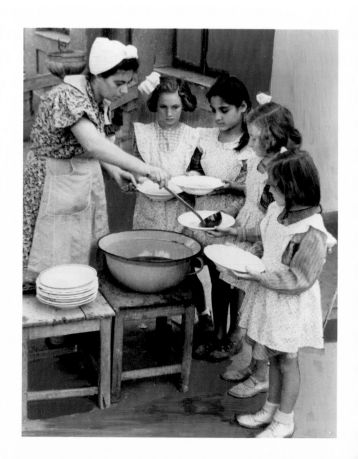

AFFLICTION & REDEMPTION

BEFORE OUR ANCESTORS learned to believe in God they worshipped idols, as the Bible tells us in the Book of Joshua: "Long ago your ancestors — Terach, the father of Abraham and Nahor — lived beyond the River, where they worshipped idols.

מִתְּחִלָּה עוֹבְדֵי עֲבוֹדָה זָרָה הָיוּ אֲבוֹתֵינוּ, וְעַכְשָׁו קֵרְבָנוּ הַמָּקוֹם לַעֲבוֹדָתוֹ, שֶׁנֶּאֱמַר: וַיֹּאמֶר יְהוֹשֻׁעַ אֶל־כָּל־הָעָם. כֹּה אָמַר יְיָ אֱלֹהֵי יִשְׂרָאֵל, בְּעֵבֶר הַנָּהָר יָשְׁבוּ אֲבוֹתֵיכֶם מֵעוֹלָם, תֶּרַח אֲבִי אַבְרָהָם וַאֲבִי נָחוֹר, וַיַּעַבְדוּ אֱלֹהִים אֲחֵרִים:

THEN GOD TOOK your father Abraham from beyond the River, led him through the whole land of Canaan, and enlarged his family by giving him a son, Isaac. Isaac had two sons, Jacob and Esau; Esau was given Mount Seir as his territory, while Jacob and his children went down to Egypt" (cf. Joshua 24:2-4).

וָאֶקַּח אֶת־אֲבִיכֶם אֶת־אַבְרָהָם מֵעֵבֶר הַנָּהָר, וָאוֹלֵךְ אוֹתוֹ בְּכָל־אֶרֶץ כְּנָעַן, וָאַרְבֶּה אֶת־זַרְעוֹ, וָאֶתֵּן לוֹ אֶת־יִצְחָק: וָאֶתֵּן לְיִצְחָק אֶת־יַעֲקֹב וְאֶת־עֵשָׂו, וָאֶתֵּן לְעֵשָׂו אֶת־הַר שֵׂעִיר, לָרֶשֶׁת אוֹתוֹ, וְיַעֲקֹב וּבָנָיו יָרְדוּ מִצְרָיִם:

BLESSED IS GOD who keeps His promise to Israel! For God foretold the end of slavery to Abraham, telling him: "You should know that your children will be strangers in a foreign land, where they shall be enslaved and oppressed for four hundred years, but I will punish the nation who oppresses them, and they shall go free with great wealth" (cf. Genesis 15:13).

בָּרוּךְ שׁוֹמֵר הַבְטָחָתוֹ לְיִשְׂרָאֵל, בָּרוּךְ הוּא. שֶׁהַקָּדוֹשׁ בָּרוּךְ הוּא חִשַּׁב אֶת־הַקֵּץ, לַעֲשׂוֹת כְּמָה שֶׁאָמַר לְאַבְרָהָם אָבִינוּ בִּבְרִית בֵּין הַבְּתָרִים. שֶׁנֶּאֱמַר: וַיֹּאמֶר לְאַבְרָם יָדֹעַ תֵּדַע כִּי־גֵר יִהְיֶה זַרְעֲךָ בְּאֶרֶץ לֹא לָהֶם, וַעֲבָדוּם וְעִנּוּ אֹתָם אַרְבַּע מֵאוֹת שָׁנָה: וְגַם אֶת־הַגּוֹי אֲשֶׁר יַעֲבֹדוּ דָּן אָנֹכִי, וְאַחֲרֵי כֵן יֵצְאוּ בִּרְכֻשׁ גָּדוֹל:

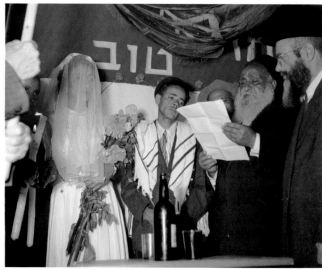

In Israel and elsewhere, JDC has endeavored to relieve affliction and improve the quality of life for those with disabilities, bringing joy to the face of a young boy who has broken through the sound barrier, and gainful employment to those seeking independence and self-respect. TOP LEFT: At a facility for hearing-impaired children. *Israel, 1968.* TOP RIGHT: Wedding of Chaim Arusi. *Israel, 1950s.* BOTTOM RIGHT and FAR RIGHT: At sheltered workshops established by *MALBEN. Israel, 1950s.*

THE HAGGADAH IS A STUDY in compassion. An oppressed people cry out and their prayers are answered. The Israelites are rescued, sheltered, fed, clothed, given a blueprint for good living and led to a new land.

Page after page, the Haggadah serves as a lesson in how to treat the downtrodden. An enslaved people are given not only freedom but dignity and respect.

With the creation of the State of Israel in 1948, the task of caring for its most needy immigrants — the elderly and the disabled — was taken up by the JDC through the Organization for the Care of Handicapped Immigrants, better known by its Hebrew acronym, *MALBEN.* With the young state trying to absorb hundreds of thousands of Jewish refugees from Europe and the Middle East, the needs were immense. By one estimate, fewer than 50 percent of the newcomers were able-bodied adults.

MALBEN's goals were twofold: to care for those in need and to teach skills to those who could become self-sufficient. Pictured here are: a deaf boy learning to talk, a young blind woman weaving in a sheltered workshop and a man in a machine shop

who lost the use of his legs. There were also services for the blind, including an entire village, known as Kfar Uriel ("G-d is My Light" Village), that was established in the 1950s for families that were headed by a blind person. In their native villages, most of these heads of household would be forced to beg for a living, but here they were taught a trade and became self-sufficient.

One story from that era involved a young handicapped man, Chaim Arusi, who was considered a hopeless cripple in his native Yemen. But when he came to Israel, *MALBEN's* doctors believed that he could walk again. It took four years of operations, recovery, rehabilitation and care. He left their care, found a job, began to make a living and fell in love with another Yemenite immigrant. He felt so connected and indebted to *MALBEN* for its life-giving care that he returned for his wedding. Pictured here is the wedding ceremony at the *MALBEN* home, in the community of Machane Israel.

In 1975, after 25 years of running the organization, the JDC handed *MALBEN's* programs over to the State of Israel, which absorbed them into its social services.

Cover the matzah and raise the wine cup.

THE SAME PROMISE made to our ancestors holds true for us, for not just one enemy wanted to destroy us, but in every generation there are those who seek our destruction; but God saves us from their hands.

Set down the wine cup and uncover the matzah.

LOOK WHAT LABAN the Aramean tried to do to our father Jacob! While Pharaoh decreed that only Israelite boys should be thrown into the Nile, Laban tried to destroy the entire people, as the Torah tells us, "An Aramean tried to destroy my father, so he went down to Egypt and dwelt there, few in numbers; but there he became a nation, great, mighty and numerous" (cf. Deuteronomy 26:5).

He went down to Egypt – forced by God's decree, "Your children will be strangers in a foreign land, where they shall be enslaved and oppressed for four hundred years." **And dwelt there** - This teaches us that Jacob did not intend to settle permanently in Egypt, but to stay there for a short while, as Jacob's sons said to Pharaoh, "We have come to sojourn in the land, for there is no pasture for our flocks, since the famine is severe in the land of Canaan. Please let us stay in the land of Goshen" (cf. Genesis 47:4).

Few in numbers - As the Torah tells us, "Your fathers went down to Egypt with seventy persons, and now God has made you as numerous as the stars in the sky" (Deuteronomy 10:22).

There he became a nation - This teaches us that Israel was distinguished there.

Great and mighty - As the Torah tells us, "The children of Israel were fruitful and multiplied, and increased and became very strong and numerous, and the land was filled with them" (Exodus 1:7).

And numerous - As the prophet said, "I made you flourish like the bud of the field, and you became numerous and grew big..." (Ezekiel 16:7).

וְהִיא שֶׁעָמְדָה לַאֲבוֹתֵינוּ וְלָנוּ. שֶׁלֹא אֶחָד בִּלְבָד עָמַד עָלֵינוּ לְכַלּוֹתֵנוּ, אֶלָּא שֶׁבְּכָל דּוֹר וָדוֹר עוֹמְדִים עָלֵינוּ לְכַלּוֹתֵנוּ, וְהַקָּדוֹשׁ בָּרוּךְ הוּא מַצִּילֵנוּ מִיָּדָם:

צֵא וּלְמַד מַה בִּקֵּשׁ לָבָן הָאֲרַמִּי לַעֲשׂוֹת לְיַעֲקֹב אָבִינוּ. שֶׁפַּרְעֹה לֹא גָזַר אֶלָּא עַל הַזְּכָרִים, וְלָבָן בִּקֵּשׁ לַעֲקֹר אֶת־הַכֹּל, שֶׁנֶּאֱמַר: אֲרַמִּי אֹבֵד אָבִי, וַיֵּרֶד מִצְרַיְמָה, וַיָּגָר שָׁם בִּמְתֵי מְעָט. וַיְהִי שָׁם לְגוֹי גָּדוֹל, עָצוּם וָרָב:

וַיֵּרֶד מִצְרַיְמָה, אָנוּס עַל פִּי הַדִּבּוּר. וַיָּגָר שָׁם. מְלַמֵּד שֶׁלֹא יָרַד יַעֲקֹב אָבִינוּ לְהִשְׁתַּקֵּעַ בְּמִצְרַיִם, אֶלָּא לָגוּר שָׁם. שֶׁנֶּאֱמַר: וַיֹּאמְרוּ אֶל־פַּרְעֹה, לָגוּר בָּאָרֶץ בָּאנוּ, כִּי אֵין מִרְעֶה לַצֹּאן אֲשֶׁר לַעֲבָדֶיךָ, כִּי כָבֵד הָרָעָב בְּאֶרֶץ כְּנָעַן, וְעַתָּה יֵשְׁבוּ־נָא עֲבָדֶיךָ בְּאֶרֶץ גּשֶׁן:

בִּמְתֵי מְעָט. כְּמָה שֶׁנֶּאֱמַר: בְּשִׁבְעִים נֶפֶשׁ יָרְדוּ אֲבֹתֶיךָ מִצְרַיְמָה, וְעַתָּה שָׂמְךָ יְיָ אֱלֹהֶיךָ כְּכוֹכְבֵי הַשָּׁמַיִם לָרֹב.

וַיְהִי שָׁם לְגוֹי. מְלַמֵּד שֶׁהָיוּ יִשְׂרָאֵל מְצֻיָּנִים שָׁם:

גָּדוֹל עָצוּם. כְּמָה שֶׁנֶּאֱמַר: וּבְנֵי יִשְׂרָאֵל פָּרוּ וַיִּשְׁרְצוּ וַיִּרְבּוּ וַיַּעַצְמוּ בִּמְאֹד מְאֹד, וַתִּמָּלֵא הָאָרֶץ אֹתָם:

וָרָב. כְּמָה שֶׁנֶּאֱמַר: רְבָבָה כְּצֶמַח הַשָּׂדֶה נְתַתִּיךְ, וַתִּרְבִּי, וַתִּגְדְּלִי, וַתָּבֹאִי בַּעֲדִי עֲדָיִים: שָׁדַיִם נָכֹנוּ, וּשְׂעָרֵךְ צִמֵּחַ, וְאַתְּ עֵרֹם וְעֶרְיָה:

IN THE EARLY 1980s, *following the Ethiopian government's closure of the ORT program, JDC sought to recreate a lifeline to Ethiopian Jewry, a long-suffering community in one of the world's poorest countries. In 1983, amid a deepening famine, it was granted permission to operate relief and recovery activities on a non-sectarian basis in the hard-hit Gondar region, the area with the largest number of Ethiopian Jews. The goodwill subsequently earned through its medical activities and development projects enabled JDC to begin engaging the Jewish population more directly, distributing matzah for Passover and other items for Jewish holidays, building new synagogues, and aiding local families through various synagogue-related projects.*

A handwritten letter in the JDC Archives, dated May 24, 1985, and signed in Hebrew by one who calls himself "Your Brother," movingly attests to the value of this assistance:

A young boy in Gondar delightedly grasps a box of Passover matzah supplied by JDC. *Ethiopia, 1988.* Photo: Michael Schneider

"Now again thank you, thank you very much for your kindness, aid and good remark....As I've written to you before our country is in drought, whereas though we're poor, your help, with God's aid, help us to (be) saved from famine. Thank you too."

The Egyptians dealt harshly with us and oppressed us; they imposed heavy labor on us.

וַיָּרֵעוּ אֹתָנוּ הַמִּצְרִים וַיְעַנּוּנוּ, וַיִּתְּנוּ עָלֵינוּ עֲבֹדָה קָשָׁה:

The Egyptians dealt harshly with us – As Pharaoh said, "Come, let us deal shrewdly with them, lest they increase even more. In the event of war, they might join our enemies in fighting against us and take over the country" (Exodus 1:10).

וַיָּרֵעוּ אֹתָנוּ הַמִּצְרִים. כְּמָה שֶׁנֶּאֱמַר: הָבָה נִתְחַכְּמָה לוֹ פֶּן־יִרְבֶּה, וְהָיָה כִּי־תִקְרֶאנָה מִלְחָמָה, וְנוֹסַף גַּם הוּא עַל־שֹׂנְאֵינוּ, וְנִלְחַם־בָּנוּ וְעָלָה מִן־הָאָרֶץ:

And oppressed us – As the Torah tells us, "The Egyptians set taskmasters over them to oppress them with forced labor; and they built the treasure cities of Pithom and Raamses for Pharaoh" (Exodus 1:11). *They imposed heavy labor on us* – As the Torah tells us, "The Egyptians ruthlessly enslaved the Israelites" (Exodus 1:13).

וַיְעַנּוּנוּ. כְּמָה שֶׁנֶּאֱמַר: וַיָּשִׂימוּ עָלָיו שָׂרֵי מִסִּים, לְמַעַן עַנֹּתוֹ בְּסִבְלֹתָם: וַיִּבֶן עָרֵי מִסְכְּנוֹת לְפַרְעֹה, אֶת־פִּתֹם וְאֶת־רַעַמְסֵס: וַיִּתְּנוּ עָלֵינוּ עֲבֹדָה קָשָׁה. כְּמָה שֶׁנֶּאֱמַר: וַיַּעֲבִדוּ מִצְרַיִם אֶת־בְּנֵי יִשְׂרָאֵל בְּפָרֶךְ:

We cried to the God of our fathers; God heard our plea and saw our plight, our misery and our oppression.

וַנִּצְעַק אֶל יְיָ אֱלֹהֵי אֲבֹתֵינוּ, וַיִּשְׁמַע יְיָ אֶת־קֹלֵנוּ. וַיַּרְא אֶת־עָנְיֵנוּ, וְאֶת־עֲמָלֵנוּ. וְאֶת לַחֲצֵנוּ:

We cried to the God of our fathers – As the Torah tells us, "A long time after that, the king of Egypt died. The Israelites groaned under their slavery and cried out, and their cry for help from slavery rose up to God"(Exodus 2:23).

וַנִּצְעַק אֶל־יְיָ אֱלֹהֵי אֲבֹתֵינוּ, כְּמָה שֶׁנֶּאֱמַר: וַיְהִי בַיָּמִים הָרַבִּים הָהֵם, וַיָּמָת מֶלֶךְ מִצְרַיִם, וַיֵּאָנְחוּ בְנֵי־יִשְׂרָאֵל מִן הָעֲבֹדָה וַיִּזְעָקוּ. וַתַּעַל שַׁוְעָתָם אֶל־הָאֱלֹהִים מִן הָעֲבֹדָה:

God heard our plea - As the Torah tells us, "God heard their groaning, and God remembered the promise to Abraham, to Isaac, and to Jacob" (Exodus 2:24).

וַיִּשְׁמַע יְיָ אֶת־קֹלֵנוּ. כְּמָה שֶׁנֶּאֱמַר: וַיִּשְׁמַע אֱלֹהִים אֶת־נַאֲקָתָם, וַיִּזְכֹּר אֱלֹהִים אֶת־בְּרִיתוֹ, אֶת־אַבְרָהָם, אֶת־יִצְחָק, וְאֶת יַעֲקֹב:

And saw our plight - This teaches us that husbands and wives were kept apart in Egypt, as the Torah tells us, "God looked upon the Israelites and God understood their plight" (Exodus 2:25).

וַיַּרְא אֶת־עָנְיֵנוּ: זוֹ פְּרִישׁוּת דֶּרֶךְ אֶרֶץ, כְּמָה שֶׁנֶּאֱמַר: וַיַּרְא אֱלֹהִים אֶת־בְּנֵי יִשְׂרָאֵל, וַיֵּדַע אֱלֹהִים:

Our misery – This refers to the drowning of the baby boys, as the Pharaoh said, "Every boy that is born you shall throw into the Nile, but every girl may be kept alive" (Exodus 1:22).

וְאֶת עֲמָלֵנוּ. אֵלּוּ הַבָּנִים, כְּמָה שֶׁנֶּאֱמַר: כָּל הַבֵּן הַיִּלּוֹד הַיְאֹרָה תַּשְׁלִיכֻהוּ, וְכָל הַבַּת תְּחַיּוּן:

And our oppression – As the Torah tells us, "Moreover, I have seen how the Egyptians oppress them" (Exodus 3:9).

וְאֶת לַחֲצֵנוּ. זֶה הַדְּחַק, כְּמָה שֶׁנֶּאֱמַר: וְגַם־רָאִיתִי אֶת־הַלַּחַץ, אֲשֶׁר מִצְרַיִם לֹחֲצִים אֹתָם:

God freed us from Egypt with a strong hand, with an outstretched arm, with great awe and with signs and wonders.

וַיּוֹצִאֵנוּ יְיָ מִמִּצְרַיִם. בְּיָד חֲזָקָה, וּבִזְרֹעַ נְטוּיָה, וּבְמֹרָא גָּדֹל וּבְאֹתוֹת וּבְמֹפְתִים:

God freed us from Egypt - Not through an angel or a messenger, but by God personally, as the Torah tells us, "For I will pass through the land of Egypt on that night and slay every first-born in the land of Egypt, both man and beast, and I will punish all the gods of Egypt, I Myself" (Exodus 12:12).

וַיּוֹצִאֵנוּ יְיָ מִמִּצְרַיִם. לֹא עַל־יְדֵי מַלְאָךְ, וְלֹא עַל־יְדֵי שָׂרָף, וְלֹא עַל־יְדֵי שָׁלִיחַ, אֶלָּא הַקָּדוֹשׁ בָּרוּךְ הוּא בִּכְבוֹדוֹ וּבְעַצְמוֹ, שֶׁנֶּאֱמַר: וְעָבַרְתִּי בְאֶרֶץ מִצְרַיִם בַּלַּיְלָה הַזֶּה, וְהִכֵּיתִי כָל־בְּכוֹר בְּאֶרֶץ מִצְרַיִם, מֵאָדָם וְעַד בְּהֵמָה, וּבְכָל־אֱלֹהֵי מִצְרַיִם אֶעֱשֶׂה שְׁפָטִים אֲנִי יְיָ:

And I will pass through the land of Egypt – Myself and not an angel, I will slay all the first-born, myself and not through a messenger, and I will punish all the gods of Egypt, myself and not a messenger, I am the Lord, and none other.

With a strong hand – This refers to the plague of cattle disease, as the Torah tells us, "The hand of God will strike your livestock in the fields...with a very severe disease" (Exodus 9:3).

With an outstretched arm – This refers to the sword, as the Bible uses the word "outstretched" in the verse, "His sword is drawn in his hand, outstretched against Jerusalem" (I Chronicles 21:16).

With great awe – This refers to God's appearance to the people, as the Torah tells us, "Has any god ever tried to take one nation from the midst of another nation, by tests, by signs and wonders, by war, with a strong hand and an outstretched arm, and with great awe, as God did for you in Egypt before your very eyes?" (Deuteronomy 4:34).

And with signs – This refers to the staff of Moses, as the Torah tells us, "And take with you this staff, with which you shall perform the signs" (Exodus 4:17).

And wonders – This refers to the plague of blood, as the Torah tells us, "I will show wonders in heaven and on earth."

Spill a drop of wine as each of the following is recited:

BLOOD, FIRE, and PILLARS OF SMOKE" (Joel 2:30).

ANOTHER INTERPRETATION of this verse:
With a strong hand refers to two plagues;
with an outstretched arm – another two;
with great awe – another two;
and with signs – another two;
and wonders – another two.

וְעָבַרְתִּי בְאֶרֶץ־מִצְרַיִם בַּלַּיְלָה הַזֶּה, אֲנִי וְלֹא מַלְאָךְ. וְהִכֵּיתִי כָל בְּכוֹר בְּאֶרֶץ־מִצְרַיִם, אֲנִי וְלֹא שָׂרָף. וּבְכָל־אֱלֹהֵי מִצְרַיִם אֶעֱשֶׂה שְׁפָטִים. אֲנִי וְלֹא הַשָּׁלִיחַ. אֲנִי יְיָ. אֲנִי הוּא וְלֹא אַחֵר:

בְּיָד חֲזָקָה. זוֹ הַדֶּבֶר, כְּמָה שֶׁנֶּאֱמַר: הִנֵּה יַד־יְיָ הוֹיָה, בְּמִקְנְךָ אֲשֶׁר בַּשָּׂדֶה, בַּסּוּסִים בַּחֲמֹרִים בַּגְּמַלִּים. בַּבָּקָר וּבַצֹּאן, דֶּבֶר כָּבֵד מְאֹד:

וּבִזְרֹעַ נְטוּיָה. זוֹ הַחֶרֶב, כְּמָה שֶׁנֶּאֱמַר: וְחַרְבּוֹ שְׁלוּפָה בְּיָדוֹ, נְטוּיָה עַל־יְרוּשָׁלַיִם:

וּבְמֹרָא גָּדֹל. זֶה גִּלּוּי שְׁכִינָה, כְּמָה שֶׁנֶּאֱמַר: אוֹ הֲנִסָּה אֱלֹהִים, לָבוֹא לָקַחַת לוֹ גוֹי מִקֶּרֶב גּוֹי, בְּמַסֹּת בְּאֹתֹת וּבְמוֹפְתִים וּבְמִלְחָמָה, וּבְיָד חֲזָקָה וּבִזְרוֹעַ נְטוּיָה, וּבְמוֹרָאִים גְּדֹלִים. כְּכֹל אֲשֶׁר־עָשָׂה לָכֶם יְיָ אֱלֹהֵיכֶם בְּמִצְרָיִם, לְעֵינֶיךָ:

וּבְאֹתוֹת. זֶה הַמַּטֶּה, כְּמָה שֶׁנֶּאֱמַר: וְאֶת הַמַּטֶּה הַזֶּה תִּקַּח בְּיָדֶךָ, אֲשֶׁר תַּעֲשֶׂה־בּוֹ אֶת הָאֹתֹת:

וּבְמֹפְתִים. זֶה הַדָּם, כְּמָה שֶׁנֶּאֱמַר: וְנָתַתִּי מוֹפְתִים, בַּשָּׁמַיִם וּבָאָרֶץ:

דָּם. וָאֵשׁ. וְתִימְרוֹת עָשָׁן:

דָּבָר אַחֵר. בְּיָד חֲזָקָה, שְׁתַּיִם. וּבִזְרֹעַ נְטוּיָה, שְׁתַּיִם. וּבְמֹרָא גָּדֹל, שְׁתַּיִם. וּבְאֹתוֹת. שְׁתַּיִם. וּבְמֹפְתִים, שְׁתַּיִם:

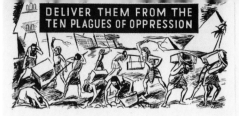

Campaign brochure for the United Jewish Appeal for Refugees, Overseas Needs and Palestine. *United States, 1940s.*

TEN PLAGUES

Spill a drop of wine as each of the ten plagues is recited:

These are the ten plagues that God brought upon the Egyptians in Egypt, namely:

אֵלּוּ עֶשֶׂר מַכּוֹת שֶׁהֵבִיא הַקָּדוֹשׁ בָּרוּךְ הוּא עַל־הַמִּצְרִים בְּמִצְרַיִם, וְאֵלּוּ הֵן:

BLOOD (Dahm)

דָּם.

FROGS (Tz'farde'a)

צְפַרְדֵּעַ.

LICE (Kinim)

כִּנִּים.

WILD BEASTS (Arov)

עָרוֹב.

DISEASE (Dever)

דֶּבֶר.

BOILS (Sh'hin)

שְׁחִין.

HAIL (Barad)

בָּרָד.

LOCUSTS (Arbeh)

אַרְבֶּה.

DARKNESS (Hoshekh)

חֹשֶׁךְ.

SLAYING OF THE FIRST-BORN (Makat B'khorot)

מַכַּת בְּכוֹרוֹת:

Rabbi Yehudah used to refer to the plagues by their first letters in Hebrew:

De'TZa'KH A'Da'SH B'A'HaV

רַבִּי יְהוּדָה הָיָה נוֹתֵן בָּהֶם סִמָּנִים:

דְּצַ"ךְ עֲדַ"שׁ בְּאַחַ"ב:

RABBI YOSSI THE GALILEAN said, "How do we know that the Egyptians suffered ten plagues in Egypt and fifty plagues at the Red Sea? In Egypt, Pharaoh's magicians said, 'This is the finger of God' (Exodus 8:15), while at the Red Sea, the Torah tells us, 'Israel saw the strong hand which God used against the Egyptians' (Exodus14:31). If the finger of God caused ten plagues in Egypt, then the hand of God caused fifty plagues at the Red Sea."

רַבִּי יוֹסֵי הַגְּלִילִי אוֹמֵר: מִנַּיִן אַתָּה אוֹמֵר, שֶׁלָּקוּ הַמִּצְרִים בְּמִצְרַיִם עֶשֶׂר מַכּוֹת, וְעַל הַיָּם, לָקוּ חֲמִשִּׁים מַכּוֹת? בְּמִצְרַיִם מָה הוּא אוֹמֵר: וַיֹּאמְרוּ הַחַרְטֻמִּם אֶל־פַּרְעֹה, אֶצְבַּע אֱלֹהִים הוּא. וְעַל הַיָּם מָה הוּא אוֹמֵר? וַיַּרְא יִשְׂרָאֵל אֶת־הַיָּד הַגְּדֹלָה, אֲשֶׁר עָשָׂה יְיָ בְּמִצְרַיִם, וַיִּירְאוּ הָעָם אֶת־יְיָ, וַיַּאֲמִינוּ בַּיְיָ, וּבְמֹשֶׁה עַבְדּוֹ. כַּמָּה לָקוּ בָּאֶצְבַּע, עֶשֶׂר מַכּוֹת: אֱמוֹר מֵעַתָּה, בְּמִצְרַיִם לָקוּ עֶשֶׂר מַכּוֹת, וְעַל־הַיָּם לָקוּ חֲמִשִּׁים מַכּוֹת:

RABBI ELIEZER said, "How do we know that every plague in Egypt was multiplied by four? Because the Bible tells us, 'God sent fierce anger, wrath, indignation, trouble, and messengers of evil against the Egyptians' (Psalms 78:49). This teaches us that each plague was accompanied by (1) wrath, (2) indignation, (3) trouble, and (4) messengers of evil. If the plagues in Egypt numbered 10 x 4 = 40, then the plagues at the Red Sea numbered 50 x 4 = 200."

רַבִּי אֱלִיעֶזֶר אוֹמֵר: מִנַּיִן שֶׁכָּל־מַכָּה וּמַכָּה, שֶׁהֵבִיא הַקָּדוֹשׁ בָּרוּךְ הוּא עַל הַמִּצְרִים בְּמִצְרַיִם, הָיְתָה שֶׁל אַרְבַּע מַכּוֹת? שֶׁנֶּאֱמַר: יְשַׁלַּח־בָּם חֲרוֹן אַפּוֹ, עֶבְרָה וָזַעַם וְצָרָה, מִשְׁלַחַת מַלְאֲכֵי רָעִים. עֶבְרָה אַחַת. וָזַעַם שְׁתַּיִם. וְצָרָה שָׁלֹשׁ. מִשְׁלַחַת מַלְאֲכֵי רָעִים אַרְבַּע: אֱמוֹר מֵעַתָּה, בְּמִצְרַיִם לָקוּ אַרְבָּעִים מַכּוֹת. וְעַל הַיָּם לָקוּ מָאתַיִם מַכּוֹת:

RABBI AKIVA said, "How do we know that every plague in Egypt was multiplied by five? Because the verse, 'God sent fierce anger, wrath, indignation, trouble, and messengers of evil against the Egyptians' (Psalms 78:49), may mean that each plague was accompanied by (1) fierce anger, (2) wrath, (3) indignation, (4) trouble, and (5) messengers of evil. If the plagues in Egypt numbered 10 x 5 = 50, then the plagues at the Red Sea numbered 50 x 5 = 250."

רַבִּי עֲקִיבָא אוֹמֵר: מִנַּיִן שֶׁכָּל־מַכָּה וּמַכָּה, שֶׁהֵבִיא הַקָּדוֹשׁ בָּרוּךְ הוּא עַל הַמִּצְרִים בְּמִצְרַיִם, הָיְתָה שֶׁל חָמֵשׁ מַכּוֹת? שֶׁנֶּאֱמַר: יְשַׁלַּח־בָּם חֲרוֹן אַפּוֹ, עֶבְרָה וָזַעַם וְצָרָה, מִשְׁלַחַת מַלְאֲכֵי רָעִים. חֲרוֹן אַפּוֹ אַחַת. עֶבְרָה שְׁתַּיִם. וָזַעַם שָׁלֹשׁ. וְצָרָה אַרְבַּע. מִשְׁלַחַת מַלְאֲכֵי רָעִים חָמֵשׁ: אֱמוֹר מֵעַתָּה, בְּמִצְרַיִם לָקוּ חֲמִשִּׁים מַכּוֹת. וְעַל הַיָּם לָקוּ חֲמִשִּׁים וּמָאתַיִם מַכּוֹת:

DAYENU

How many great things God has done for us!

Had God freed us from Egypt,
but not punished the Egyptians - ***Dayenu!***

Had God punished the Egyptians,
but not proven their gods false - ***Dayenu!***

Had God proven their gods false,
but not slain their first-born - ***Dayenu!***

Had God slain their first-born,
but not given us their treasure - ***Dayenu!***

Had God given us their treasure,
but not split the Red Sea - ***Dayenu!***

Had God split the Red Sea,
but not brought us through on dry land - ***Dayenu!***

דַּיֵּנוּ

כַּמָּה מַעֲלוֹת טוֹבוֹת לַמָּקוֹם עָלֵינוּ:

אִלּוּ הוֹצִיאָנוּ מִמִּצְרַיִם,
וְלֹא עָשָׂה בָהֶם שְׁפָטִים. דַּיֵּנוּ:

אִלּוּ עָשָׂה בָהֶם שְׁפָטִים.
וְלֹא עָשָׂה בֵאלֹהֵיהֶם. דַּיֵּנוּ:

אִלּוּ עָשָׂה בֵאלֹהֵיהֶם.
וְלֹא הָרַג אֶת־בְּכוֹרֵיהֶם. דַּיֵּנוּ:

אִלּוּ הָרַג אֶת־בְּכוֹרֵיהֶם.
וְלֹא נָתַן לָנוּ אֶת־מָמוֹנָם. דַּיֵּנוּ:

אִלּוּ נָתַן לָנוּ אֶת־מָמוֹנָם.
וְלֹא קָרַע לָנוּ אֶת־הַיָּם. דַּיֵּנוּ:

אִלּוּ קָרַע לָנוּ אֶת־הַיָּם,
וְלֹא הֶעֱבִירָנוּ בְּתוֹכוֹ בֶּחָרָבָה, דַּיֵּנוּ:

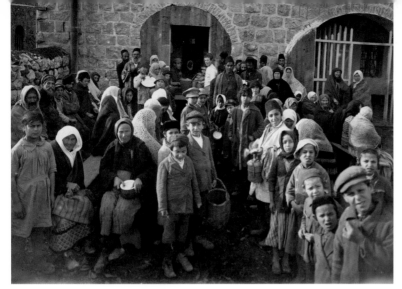

ABOVE:
Aid programs early on helped meet basic needs, like the 900 meals provided each day at the Dreyfus soup kitchen in Jerusalem. *Palestine, 1921.*

LEFT:
Clothing distribution programs have long given elderly Jews in Europe the blankets and warm clothing they need to survive the continent's harsh winters. *The Baltics, 1999.* Photo: Roy Mittelman

ABOVE:
Getting a new pair of shoes is a big event in the lives of these refugee Jewish youngsters in postwar Berlin. *Germany, circa 1946.* Photo: Al Taylor

OPPOSITE PAGE:
The first shipment of Torah scrolls donated by American Jewry for use in the liberated Jewish communities of Europe; those pictured here were sent to Jews struggling to reconstruct communal life in France, Italy, and Greece. *United States, 1946.*

"IT WOULD HAVE BEEN ENOUGH." In Dayenu we praise God for each step in the process of redemption – from the Exodus, to shelter in the desert, to Sinai, to arrival in the Holy Land. Deliverance does not come in one flash of benevolence but in incremental steps that take us to where we have to go.

Two steps along the way of modern redemption are worth noting here: campaigns for clothing and efforts to restore lost Torah scrolls. According to the Midrash, in the 40 years of travel through the desert, the clothes of the Israelites never wore out. Shoes never wore down and clothing never frayed. As children grew, the clothes grew with them, we are told.

Not so in modern times. Clothing modern-day refugees has been a major project of the JDC. In 1946, the Joint initiated an emergency program called S.O.S., which stood for Supplies for Overseas Survivors. It called on American Jews to give personal items "over and above any financial participation in the United Jewish Appeal" or other charities. It called for a massive public response to send "food, clothing and creature comforts."

"The S.O.S. collection will enable American Jewry to share, with these survivors, on a personal basis, its abundance," the organizers of the effort explained.

Collection centers were set up around the country. Women's groups were mobilized to sew, knit, pack and ship supplies. Even Henry Fonda was enlisted to help in the effort, donating suits of his own and encouraging others to join him.

The response was extraordinary. In the two years ending June 1, 1948, tons and tons of clothing, food and medical and other relief supplies were gathered and shipped overseas.

The JDC also worked to accommodate the spiritual needs of the refugees. In 1946, it organized an effort to have every Jewish congregation in America donate a Torah scroll to replace ones destroyed by the Nazis. "I need not stress the importance of Scrolls of the Law for the saved remnant of our people in Europe," Rabbi Leo Jung wrote on behalf of the JDC. "In the night of deepest darkness, the Torah gave us light. In periods of utter coldness, the Torah gave us warmth." He urged synagogues to donate so that the Torah's message "of justice and love may be radiated to all God's children everywhere."

The response from congregations was unprecedented. Orthodox, Conservative and Reform synagogues opened their arks and storage spaces and sent some 500 Torah scrolls. At a ceremony held later that year in Paris, 33 French Jewish communities received Torahs as gifts from 33 American Jewish communities.

Just as a person cannot survive long without clothing, a Jewish community cannot function without a Torah. Each step along the way toward rehabilitation is essential.

Had God brought us through on dry land,	אֵלּוּ הֶעֱבִירָנוּ בְּתוֹכוֹ בֶּחָרָבָה,
but not drowned our oppressors – **Dayenu!**	וְלֹא שִׁקַּע צָרֵינוּ בְּתוֹכוֹ, דַּיֵּנוּ:

Had God drowned our oppressors,	אֵלּוּ שִׁקַּע צָרֵינוּ בְּתוֹכוֹ, וְלֹא
but not helped us for forty years in the wilderness – **Dayenu!**	סִפֵּק צָרְכֵּנוּ בַּמִּדְבָּר אַרְבָּעִים שָׁנָה, דַּיֵּנוּ:

Had God helped us for forty years in the wilderness,	אֵלּוּ סִפֵּק צָרְכֵּנוּ בַּמִּדְבָּר אַרְבָּעִים שָׁנָה,
but not fed us with manna – **Dayenu!**	וְלֹא הֶאֱכִילָנוּ אֶת־הַמָּן, דַּיֵּנוּ:

Had God fed us with manna,	אֵלּוּ הֶאֱכִילָנוּ אֶת־הַמָּן,
but not given us the Shabbat – **Dayenu!**	וְלֹא נָתַן לָנוּ אֶת־הַשַּׁבָּת, דַּיֵּנוּ:

Had God given us the Shabbat,	אֵלּוּ נָתַן לָנוּ אֶת־הַשַּׁבָּת,
but not brought us to Mount Sinai – **Dayenu!**	וְלֹא קֵרְבָנוּ לִפְנֵי הַר סִינַי, דַּיֵּנוּ:

Had God brought us to Mount Sinai,	אֵלּוּ קֵרְבָנוּ לִפְנֵי הַר סִינַי,
but not given us the Torah – **Dayenu!**	וְלֹא נָתַן לָנוּ אֶת־הַתּוֹרָה, דַּיֵּנוּ:

Had God given us the Torah,	אֵלּוּ נָתַן לָנוּ אֶת־הַתּוֹרָה,
but not brought us into the land of Israel – **Dayenu!**	וְלֹא הִכְנִיסָנוּ לְאֶרֶץ יִשְׂרָאֵל, דַּיֵּנוּ:

Had God brought us into the land of Israel,	אֵלּוּ הִכְנִיסָנוּ לְאֶרֶץ יִשְׂרָאֵל,
but not built the Temple – **Dayenu!**	וְלֹא בָּנָה לָנוּ אֶת־בֵּית הַבְּחִירָה, דַּיֵּנוּ:

LEFT:
A carefully packed Torah scroll arrives in the port of Haifa. *Palestine, 1945.*

ABOVE:
When 48,000 Yemenite Jews were airlifted to Israel in Operation Magic Carpet, their Torah scrolls went with them. *British Protectorate of Aden (now Yemen), 1948.*

RIGHT:
A congregation in New York City answers the call to donate a Torah scroll to replace those destroyed by the Nazis in Europe. *United States, 1946.*

OPPOSITE PAGE:
Religious as well as material needs have been addressed by JDC in all corners of the globe. Pictured here is a traditional ceremony marking the opening of a synagogue in the village of Gomenge, one of five built for the Ethiopian Jews then living in Gondar. *Kessim* (religious leaders) circled the synagogue seven times while holding a Torah scroll sent by United Jewish Communities of MetroWest, NJ. *Ethiopia, 1988.*

Photo: Donald M. Robinson

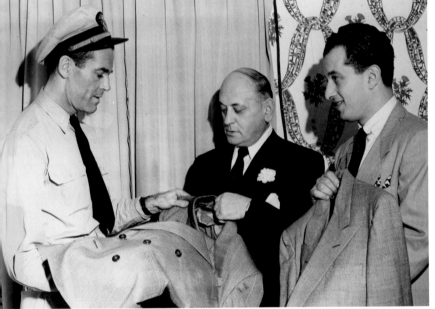

ABOVE:
Actor Henry Fonda lent his personal support to the S.O.S. campaign, helping to produce a massive outpouring of supplies for Holocaust survivors. *United States, 1948.* Photo: Murray Kass

RIGHT:
People donated goods, money, time, and talent to the effort to aid European Jews, like these women busy making clothes at an S.O.S. sewing circle in New York. *United States, 1948.*

Photo: © Ben Greenhaus/Donald Greenhaus/Shabobba® International, LLC.

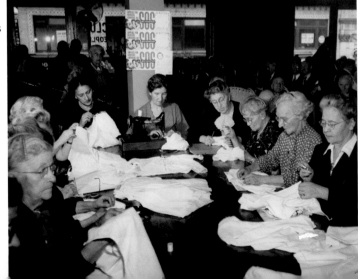

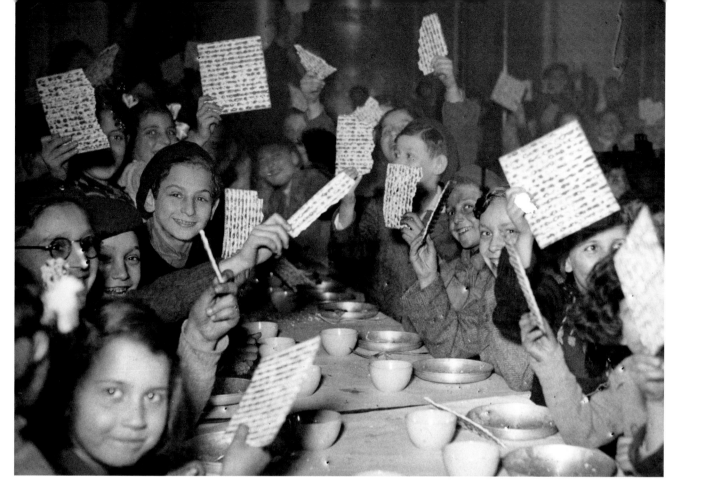

PESACH · MATZAH · MAROR

HOW MUCH MORE should we be grateful for all that God has done for us! God freed us from Egypt, and punished the Egyptians, and proved their gods false, and slew their first-born, and gave us their treasure, and split the Red Sea, and brought us through on dry land, and drowned our oppressors, and helped us for forty years in the wilderness, and fed us with manna, and gave us the Shabbat, and brought us to Mount Sinai, and gave us the Torah, and brought us into the land of Israel, and built the Temple as a place of atonement for all our sins.

RABBAN GAMLIEL used to say, "Whoever has not explained the following three symbols at the seder has not fulfilled his duty: the roasted bone (Pesach), the unleavened bread (matzah), and the bitter herbs (maror)."

עַל אַחַת כַּמָּה וְכַמָּה טוֹבָה כְפוּלָה וּמְכֻפֶּלֶת לַמָּקוֹם עָלֵינוּ:
שֶׁהוֹצִיאָנוּ מִמִּצְרַיִם, וְעָשָׂה בָהֶם שְׁפָטִים,
וְעָשָׂה בֵאלֹהֵיהֶם, וְהָרַג אֶת־בְּכוֹרֵיהֶם,
וְנָתַן לָנוּ אֶת־מָמוֹנָם, וְקָרַע לָנוּ אֶת־הַיָּם,
וְהֶעֱבִירָנוּ בְתוֹכוֹ בֶּחָרָבָה, וְשִׁקַּע צָרֵינוּ בְּתוֹכוֹ,
וְסִפֵּק צָרְכֵּנוּ בַּמִּדְבָּר אַרְבָּעִים שָׁנָה,
וְהֶאֱכִילָנוּ אֶת־הַמָּן, וְנָתַן לָנוּ אֶת־הַשַּׁבָּת,
וְקֵרְבָנוּ לִפְנֵי הַר סִינַי, וְנָתַן לָנוּ אֶת־הַתּוֹרָה,
וְהִכְנִיסָנוּ לְאֶרֶץ יִשְׂרָאֵל, וּבָנָה לָנוּ אֶת־בֵּית
הַבְּחִירָה, לְכַפֵּר עַל־כָּל־עֲוֹנוֹתֵינוּ.

רַבָּן גַּמְלִיאֵל הָיָה אוֹמֵר: כָּל שֶׁלֹּא אָמַר
שְׁלֹשָׁה דְבָרִים אֵלּוּ בַּפֶּסַח,
לֹא יָצָא יְדֵי חוֹבָתוֹ, וְאֵלּוּ הֵן:

פֶּסַח. מַצָּה וּמָרוֹר:

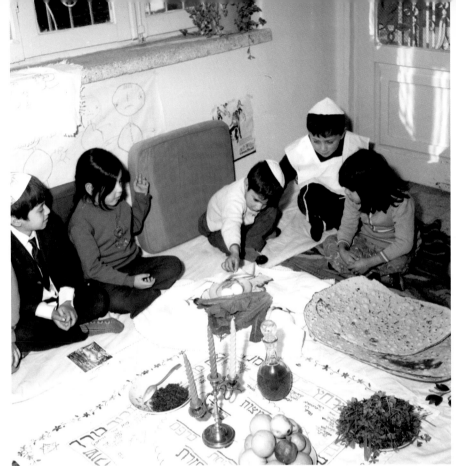

ABOVE:
The matzah tastes good at this communal seder at the Balint Jewish Community Center in Budapest. *Hungary, 2000.*
Photo: Roy Mittelman

LEFT:
Kindergartners in Tehran prepare for Passover at a model seder, using matzah that they baked themselves. *Iran, 1971.*

OPPOSITE PAGE:
Cared for by the Fédération des Sociétés Juives en France, these refugee and French Jewish orphans happily celebrate Passover together. *France, 1947.*

MOST PEOPLE DON'T THINK OF MATZAH as a flag, but the Jewish children in the accompanying picture from a children's home in France in 1947, felt free to wave it all over the place with glee. One can only imagine the journey that it took to get them here. One can only wonder with trepidation why there seem to be no adults at this Passover meal. But the joy on the faces of these children is evident.

It is time to eat. And whether it was by the light of a kerosene lamp in an internment camp in Cyprus in 1947, in Shanghai in 1950, in Iran in 1971, in Hungary in 2000 or in Israel today, the first crunch of matzah is the sign that the seder meal is about to begin.

We begin with matzah, then taste the bitter herb known as maror, adding just a drop of sweet haroset to offset its sting. And then we combine all three elements – matzah, maror and charoset – and eat them in the famous Hillel sandwich. The main course is not far behind.

Up until this point in the seder, the talk has been largely scripted. Even the questions and answers are laid out in an orderly fashion. But as we relax over the meal, new, more open and spontaneous discussion follows.

In the early 1970s, the leaders of the movement to free Soviet Jews encouraged families to leave empty seats at their seder table. The question it was supposed to evoke was: "Why are these seats empty?"

In the accompanying photo taken in Israel in 1971, there were three unexpected guests — a young woman, her husband and her 11-year-old brother — who had arrived in Israel less than two weeks earlier. The boy has risen to ask the Four Questions. The seder was held at the Frieda Schiff-Warburg Home for the Aged in Netanya, which was run by JDC-*MALBEN*.

That night, the empty seats reserved for the Soviet Jews had been filled.

Israel, 1971.

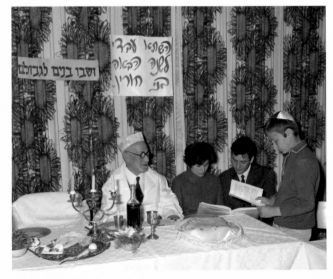

The leader points to the shank bone.

WHY DID OUR ANCESTORS eat the Pesach lamb when the Temple in Jerusalem was still standing? As a reminder of when God passed over (*pasach*) our homes in Egypt at the slaying of the first-born, as the Torah teaches us, "You shall tell your children, 'This is the Pesach offering to God, who passed over the houses of the Israelites in Egypt in slaying the Egyptians, but spared our houses'" (Exodus 12:27).

The leader raises the broken piece of matzah.

WHY DO WE EAT this matzah? As a reminder that our ancestors' dough did not have time to rise before they were hurried out of Egypt, as the Torah teaches us, "They baked unleavened bread (*matzot*) from the dough they had brought out of Egypt, for the dough had not leavened when they were rushed out of Egypt and could not wait, nor had they prepared any food for the journey" (Exodus 12:39).

*The leader raises the bitter herb (*maror*).*

WHY DO WE EAT this bitter herb (*maror*)? As a reminder that the Egyptians embittered our ancestors' lives, as the Torah teaches us, "They embittered their lives with hard labor at mortar and bricks and all sorts of work in the field, with all the tasks with which they ruthlessly enslaved them" (Exodus 1:14).

IN EVERY GENERATION we should imagine that we ourselves were freed from Egypt, as the Torah teaches us, "This is because of what God did for *me* when I went free from Egypt" (Exodus 13:8). God not only saved our ancestors from slavery, but he freed us, too, as the Torah tells us, "God freed us from there in order to bring us here and give us the land promised to our ancestors" (Deuteronomy 6:23).

Cover the matzah, lift the wine cup and recite:

THEREFORE WE THANK and praise God for all the miracles performed for our ancestors and for us. God took us from slavery to freedom, from misery to joy,

פֶּסַח שֶׁהָיוּ אֲבוֹתֵינוּ אוֹכְלִים בִּזְמַן שֶׁבֵּית הַמִּקְדָּשׁ הָיָה קַיָּם, עַל שׁוּם מָה? עַל שׁוּם שֶׁפָּסַח הַקָּדוֹשׁ בָּרוּךְ הוּא עַל בָּתֵּי אֲבוֹתֵינוּ בְּמִצְרַיִם, שֶׁנֶּאֱמַר: וַאֲמַרְתֶּם זֶבַח פֶּסַח הוּא לַיְיָ, אֲשֶׁר פָּסַח עַל בָּתֵּי בְנֵי יִשְׂרָאֵל בְּמִצְרַיִם בְּנָגְפּוֹ אֶת מִצְרַיִם וְאֶת בָּתֵּינוּ הִצִּיל, וַיִּקֹּד הָעָם וַיִּשְׁתַּחֲווּ.

מַצָּה זוֹ שֶׁאָנוּ אוֹכְלִים, עַל שׁוּם מָה? עַל שׁוּם שֶׁלֹּא הִסְפִּיק בְּצֵקָם שֶׁל אֲבוֹתֵינוּ לְהַחֲמִיץ, עַד שֶׁנִּגְלָה עֲלֵיהֶם מֶלֶךְ מַלְכֵי הַמְּלָכִים, הַקָּדוֹשׁ בָּרוּךְ הוּא, וּגְאָלָם, שֶׁנֶּאֱמַר: וַיֹּאפוּ אֶת הַבָּצֵק, אֲשֶׁר הוֹצִיאוּ מִמִּצְרַיִם, עֻגֹת מַצּוֹת, כִּי לֹא חָמֵץ: כִּי גֹרְשׁוּ מִמִּצְרַיִם, וְלֹא יָכְלוּ לְהִתְמַהְמֵהַּ, וְגַם צֵדָה לֹא עָשׂוּ לָהֶם.

מָרוֹר זֶה שֶׁאָנוּ אוֹכְלִים, עַל שׁוּם מָה? עַל שׁוּם שֶׁמֵּרְרוּ הַמִּצְרִים אֶת חַיֵּי אֲבוֹתֵינוּ בְּמִצְרַיִם, שֶׁנֶּאֱמַר: וַיְמָרְרוּ אֶת חַיֵּיהֶם בַּעֲבֹדָה קָשָׁה, בְּחֹמֶר וּבִלְבֵנִים, וּבְכָל עֲבֹדָה בַּשָּׂדֶה: אֵת כָּל עֲבֹדָתָם. אֲשֶׁר עָבְדוּ בָהֶם בְּפָרֶךְ.

בְּכָל דּוֹר וָדוֹר חַיָּב אָדָם לִרְאוֹת אֶת עַצְמוֹ כְּאִלּוּ הוּא יָצָא מִמִּצְרַיִם. שֶׁנֶּאֱמַר: וְהִגַּדְתָּ לְבִנְךָ בַּיּוֹם הַהוּא לֵאמֹר: בַּעֲבוּר זֶה עָשָׂה יְיָ לִי, בְּצֵאתִי מִמִּצְרָיִם. לֹא אֶת אֲבוֹתֵינוּ בִּלְבָד גָּאַל הַקָּדוֹשׁ בָּרוּךְ הוּא, אֶלָּא אַף אוֹתָנוּ גָּאַל עִמָּהֶם. שֶׁנֶּאֱמַר: וְאוֹתָנוּ הוֹצִיא מִשָּׁם. לְמַעַן הָבִיא אֹתָנוּ. לָתֶת לָנוּ אֶת הָאָרֶץ אֲשֶׁר נִשְׁבַּע לַאֲבֹתֵינוּ.

לְפִיכָךְ אֲנַחְנוּ חַיָּבִים לְהוֹדוֹת, לְהַלֵּל, לְשַׁבֵּחַ, לְפָאֵר, לְרוֹמֵם, לְהַדֵּר, לְבָרֵךְ, לְעַלֵּה וּלְקַלֵּס, לְמִי שֶׁעָשָׂה לַאֲבוֹתֵינוּ

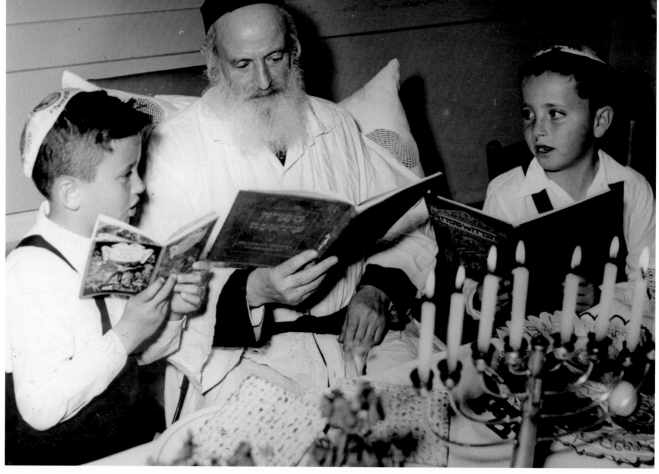

ABOVE: **In every generation:** For children born in the years immediately following the Holocaust and the establishment of the Jewish state, the Passover story of deliverance had special meaning. *Israel, 1954.*

ONE OF A LONG LINE *of Jewish heroes who have served on JDC's staff, Emmanuel Ringelblum can truly be called the Maggid (or Chronicler) of his day. A professional historian and scholar who ran JDC soup kitchens and welfare programs in the Warsaw Ghetto, Ringelblum was determined to assemble an irrefutable record for future historians of the crimes being committed by the Nazis and the enormous suffering of the Jews. In November 1940, one week after the ghetto was closed off, he organized the Oneg Shabbat Society, training its members (who met in secret on Saturday afternoons) to collect and evaluate documentary evidence of life in the ghetto and testimony from new arrivals about the resistance movement and the Nazis' depredations.*

To ensure "that the story was told," information was smuggled out of the country via the Polish underground, and the archive materials themselves were buried in milk cans that were unearthed after the war. Along with Ringelblum's own meticulous diaries, they constitute an invaluable source of information on the fate of the Jews in Nazi-occupied Poland. Though Ringelblum and his family escaped the ghetto and went into hiding shortly before the start of the historic uprising, which began on Passover 1943, he returned in the midst of the fighting and was caught and sent to a Nazi labor camp. With the help of a Polish man, Ringelblum escaped once again and was able to rejoin his family, but their hideout was discovered in March 1944. Shortly thereafter, they and other families hiding with them were murdered by the Nazis in the ruins of the ghetto.

from mourning to celebration, from darkness to great light, and from bondage to redemption. Let us sing a new song of God's praises - *Halleluyah!*

Put down the wine cup.
HALLELUYAH - PRAISE GOD!
May God's name be praised forever more!
May God's name be blessed throughout the world!
Who is glorious and mighty like God,
Who raises the poor from the dust,
Who lifts the needy from the dirt,
Seating them among the nobles.
God turns a childless woman
into a happy mother of children.
Hallelujah! (Psalms 113)

WHEN ISRAEL LEFT EGYPT -
when the House of Jacob left a foreign land -
Judah became God's holy one, Israel God's dominion.
The sea looked and fled, the Jordan turned back;
The mountains skipped like rams, the hills like lambs.
Why does the sea flee? Why does the Jordan turn back?
Why do the mountains skip like rams, the hills like lambs? It is because the entire earth trembles before the God, Who turns the rock into a pool of water, the flint to fountains. (Psalms 114)

Lift the wine cup and recite:
BLESSED ARE YOU, Lord our God,
King of the universe, who has redeemed us and our ancestors from Egypt and brought us to this night when we eat matzah and maror. May God bring us to celebrate future holidays in peace, happy in the rebuilding of Jerusalem and joyful in performing God's service; then we will sing a new song for our redemption. Blessed is God, who has redeemed Israel.

BLESSED ARE YOU, Lord our God,
King of the universe, who creates the fruit of the vine.

Barukh atah Adonai, Eloheinu melekh ha-olam, borei p'ri ha-gefen.

Drink the second cup of wine while reclining to the left.

וְלָנוּ אֶת־כָּל־הַנִּסִּים הָאֵלּוּ. הוֹצִיאָנוּ מֵעַבְדוּת לְחֵרוּת, מִיָּגוֹן לְשִׂמְחָה, וּמֵאֵבֶל לְיוֹם טוֹב, וּמֵאֲפֵלָה לְאוֹר גָּדוֹל, וּמִשִּׁעְבּוּד לִגְאֻלָּה. וְנֹאמַר לְפָנָיו שִׁירָה חֲדָשָׁה. הַלְלוּיָהּ:

הַלְלוּיָהּ הַלְלוּ עַבְדֵי יְיָ, הַלְלוּ אֶת־שֵׁם יְיָ. יְהִי שֵׁם יְיָ מְבֹרָךְ מֵעַתָּה וְעַד עוֹלָם: מִמִּזְרַח שֶׁמֶשׁ עַד מְבוֹאוֹ. מְהֻלָּל שֵׁם יְיָ. רָם עַל־ כָּל־גּוֹיִם יְיָ, עַל הַשָּׁמַיִם כְּבוֹדוֹ: מִי כַּיָי אֱלֹהֵינוּ. הַמַּגְבִּיהִי לָשָׁבֶת: הַמַּשְׁפִּילִי לִרְאוֹת בַּשָּׁמַיִם וּבָאָרֶץ: מְקִימִי מֵעָפָר דָּל, מֵאַשְׁפֹּת יָרִים אֶבְיוֹן: לְהוֹשִׁיבִי עִם־נְדִיבִים. עִם נְדִיבֵי עַמּוֹ: מוֹשִׁיבִי עֲקֶרֶת הַבַּיִת אֵם הַבָּנִים שְׂמֵחָה, הַלְלוּיָהּ:

בְּצֵאת יִשְׂרָאֵל מִמִּצְרָיִם. בֵּית יַעֲקֹב מֵעַם לֹעֵז: הָיְתָה יְהוּדָה לְקָדְשׁוֹ, יִשְׂרָאֵל מַמְשְׁלוֹתָיו: הַיָּם רָאָה וַיָּנֹס, הַיַּרְדֵּן יִסֹּב לְאָחוֹר: הֶהָרִים רָקְדוּ כְאֵילִים. גְּבָעוֹת כִּבְנֵי־צֹאן: מַה־לְּךָ הַיָּם כִּי תָנוּס. הַיַּרְדֵּן תִּסֹּב לְאָחוֹר: הֶהָרִים תִּרְקְדוּ כְאֵילִים, גְּבָעוֹת כִּבְנֵי־צֹאן: מִלִּפְנֵי אָדוֹן חוּלִי אָרֶץ, מִלִּפְנֵי אֱלוֹהַּ יַעֲקֹב: הַהֹפְכִי הַצּוּר אֲגַם־מָיִם, חַלָּמִישׁ לְמַעְיְנוֹ־מָיִם.

בָּרוּךְ אַתָּה יְיָ, אֱלֹהֵינוּ מֶלֶךְ הָעוֹלָם. אֲשֶׁר גְּאָלָנוּ וְגָאַל אֶת־אֲבוֹתֵינוּ מִמִּצְרַיִם, וְהִגִּיעָנוּ לַלַּיְלָה הַזֶּה, לֶאֱכָל־בּוֹ מַצָּה וּמָרוֹר. כֵּן, יְיָ אֱלֹהֵינוּ וֵאלֹהֵי אֲבוֹתֵינוּ. יַגִּיעֵנוּ לְמוֹעֲדִים וְלִרְגָלִים אֲחֵרִים, הַבָּאִים לִקְרָאתֵנוּ לְשָׁלוֹם, שְׂמֵחִים בְּבִנְיַן עִירֶךָ, וְשָׂשִׂים בַּעֲבוֹדָתֶךָ, וְנֹאכַל שָׁם מִן הַזְּבָחִים וּמִן הַפְּסָחִים (בְּמוֹצָאֵי שַׁבָּת אוֹמְרִים מִן הַפְּסָחִים וּמִן הַזְּבָחִים). אֲשֶׁר יַגִּיעַ דָּמָם עַל קִיר מִזְבַּחֲךָ לְרָצוֹן, וְנוֹדֶה לְךָ שִׁיר חָדָשׁ עַל גְּאֻלָּתֵנוּ וְעַל פְּדוּת נַפְשֵׁנוּ: בָּרוּךְ אַתָּה יְיָ, גָּאַל יִשְׂרָאֵל:

בָּרוּךְ אַתָּה יְיָ, אֱלֹהֵינוּ מֶלֶךְ הָעוֹלָם, בּוֹרֵא פְּרִי הַגָּפֶן:

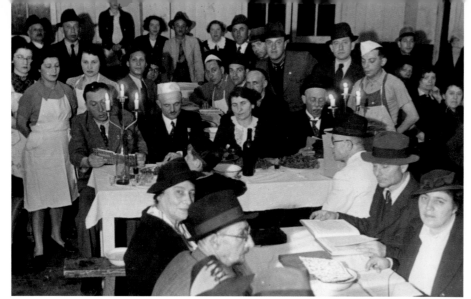

LEFT:
World War II refugees gather at a communal seder in Shanghai. *China, 1940s.*

BELOW:
An inscription on the back of this photo reads: "In memory of Passover 5702 (1942) at Caldas da Rainha (Portugal), with respectful thanks to the A.J.D.C. and the Lisbon Jewish Community, (signed) the Jewish Refugees." *Portugal, 1942.*

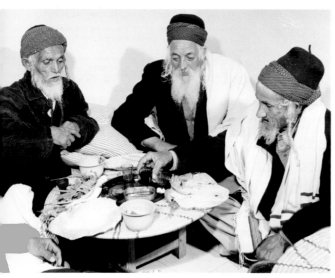

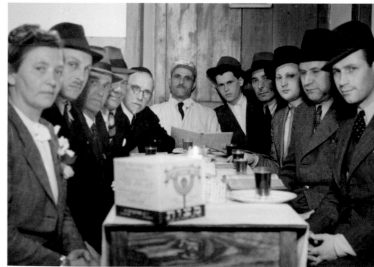

ABOVE:
A seder conducted according to Yemenite tradition at the *MALBEN* home in Sha'ar Menashe. *Israel, 1960.*

RIGHT:
With a Magen David flag adorning their April 1948 seder, the residents of this Displaced Persons camp yearn for new homes in a new land. *Germany, 1948.*

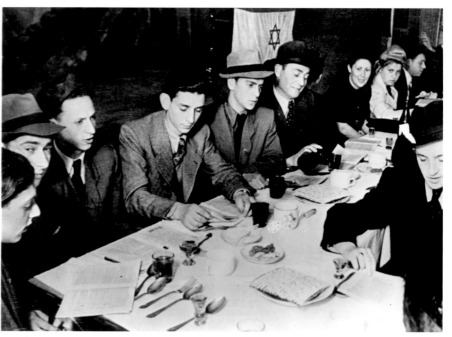

RAHTZAH

רָחְצָה

*Wash hands prior to eating matzah by pouring water
from a cup over both hands, and recite:*

BLESSED ARE YOU, Lord our God, King of the universe,
who has commanded us to wash our hands.

*Barukh atah Adonai, Eloheinu melekh ha-olam, asher kid'dishanu
bemitzvotav vetzevanu al neteilat yadayim.*

בָּרוּךְ אַתָּה יְיָ, אֱלֹהֵינוּ מֶלֶךְ הָעוֹלָם,
אֲשֶׁר קִדְּשָׁנוּ בְּמִצְוֹתָיו,
וְצִוָּנוּ עַל נְטִילַת יָדָיִם:

MOTZI • MATZAH

מוֹצִיא. מַצָּה.

The leader uncovers all three matzot, lifts them, and recites:

BLESSED ARE YOU, Lord our God, King of the universe,
who brings forth bread from the earth.

*Barukh atah Adonai, Eloheinu melekh ha-olam, ha-motzi
lechem min ha-aretz.*

בָּרוּךְ אַתָּה יְיָ, אֱלֹהֵינוּ מֶלֶךְ הָעוֹלָם.
הַמּוֹצִיא לֶחֶם מִן הָאָרֶץ:

*The leader puts down the bottom matzah and holds only the
top and broken middle matzot.*

BLESSED ARE YOU, Lord our God, King of the universe,
who has commanded us to eat matzah tonight.

*Barukh atah Adonai, Eloheinu melekh ha-olam, asher
kid'dishanu bemitzvotav vetzevanu al achilat matza.*

בָּרוּךְ אַתָּה יְיָ, אֱלֹהֵינוּ מֶלֶךְ הָעוֹלָם,
אֲשֶׁר קִדְּשָׁנוּ בְּמִצְוֹתָיו וְצִוָּנוּ עַל
אֲכִילַת מַצָּה:

*The leader distributes pieces of the top and broken middle matzot
to all participants, who eat them while reclining to the left.*

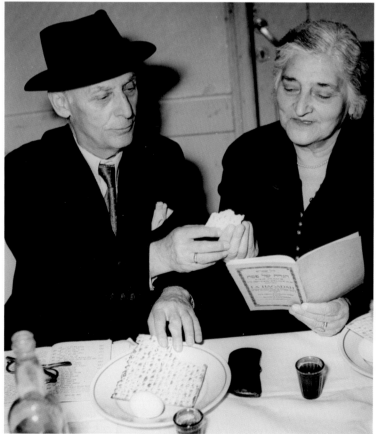

ABOVE:
One hand washes the other as these youngsters prepare to eat—at last! *Hungary, 1947.*

LEFT:
Husband and wife make the blessing together at this *MALBEN* seder in Givat Hashlosha. *Israel, 1954.*

MAROR

מָרוֹר

Dip a portion of maror (bitter herbs: romaine lettuce, endive or horseradish) in charoset and recite:

BLESSED ARE YOU, Lord our God, King of the universe, who has commanded us to eat bitter herbs tonight.

Barukh atah Adonai, Eloheinu melekh ha-olam, asher kid'dishanu bemitzvotav vetzevanu al achilat maror.

בָּרוּךְ אַתָּה יְיָ, אֱלֹהֵינוּ מֶלֶךְ הָעוֹלָם, אֲשֶׁר קִדְּשָׁנוּ בְּמִצְוֹתָיו וְצִוָּנוּ עַל אֲכִילַת מָרוֹר:

KOREKH

כּוֹרֵךְ

Place a portion of maror (and charoset) between two pieces of the bottom matzah and recite:

AS A REMINDER of the Temple in Jerusalem, we follow the custom of the sage Hillel, who used to make a sandwich of matzah and maror, in order to fulfill the words of the Torah, "They shall eat [the Pesach] together with matzot and maror.

Eat the "Hillel sandwich" while reclining to the left.

זֵכֶר לְמִקְדָּשׁ כְּהִלֵּל: כֵּן עָשָׂה הִלֵּל בִּזְמַן שֶׁבֵּית הַמִּקְדָּשׁ הָיָה קַיָּם. הָיָה כּוֹרֵךְ (פֶּסַח) מַצָּה וּמָרוֹר וְאוֹכֵל בְּיַחַד, לְקַיֵּם מַה שֶׁנֶּאֱמַר: עַל־מַצּוֹת וּמְרוֹרִים יֹאכְלֻהוּ:

SHULCHAN OREKH

שֻׁלְחָן עוֹרֵךְ

Remove the seder plate and eat the festival meal.

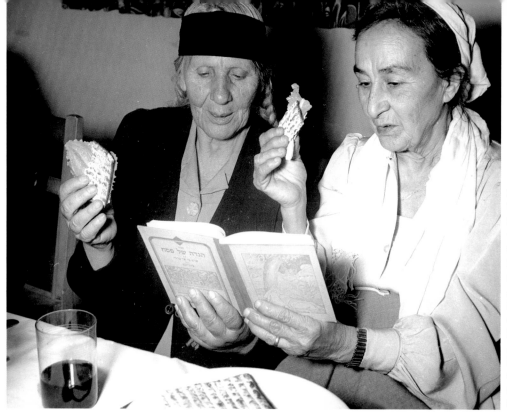

LEFT:
With "Hillel sandwiches" in hand, these two immigrants from Iraq share a Haggadah and a place of refuge in Neve Haim. *Israel, 1950s.*
BELOW:
A family conducts its seder by the glow of a lantern in a camp on Cyprus, where JDC helped care for would-be Jewish immigrants interned by the British prior to the establishment of the State of Israel. *Cyprus, 1947.*
Photo: Al Taylor

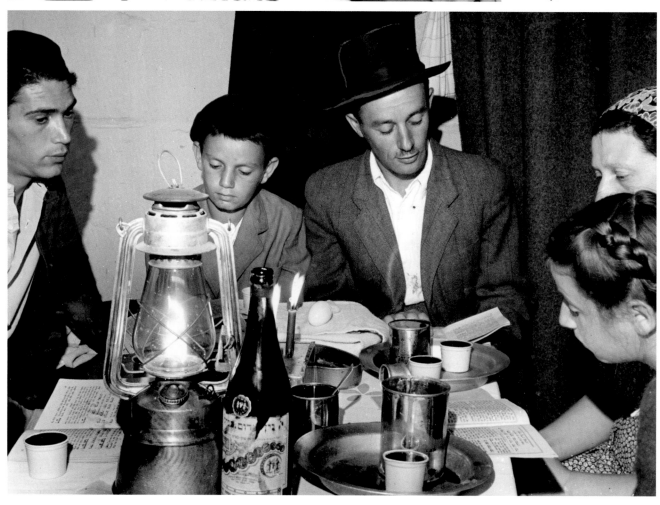

AFIKOMAN

צָפוּן

The seder plate is returned to the table. The Afikoman is found and pieces of it are distributed to everyone at the table. The Afikoman is eaten.

BIRKAT HAMAZON

בָּרֵךְ

A SONG OF ASCENTS.
When God will return the exiles of Zion, we were like dreamers. Then our mouth will be filled with laughter, and our tongue with glad song. Then will they say among the nations: "God has done great things for them." God has done great things for us, and we rejoiced. God, restore our captives, like streams in the Negev. Those who sow in tears will reap in joy. Though the farmer sows the seed in sadness, he shall come home with joy, bearing his sheaves.

שִׁיר הַמַּעֲלוֹת בְּשׁוּב יְיָ אֶת שִׁיבַת צִיּוֹן הָיִינוּ כְּחֹלְמִים: אָז יִמָּלֵא שְׂחוֹק פִּינוּ וּלְשׁוֹנֵנוּ רִנָּה, אָז יֹאמְרוּ בַגּוֹיִם הִגְדִּיל יְיָ לַעֲשׂוֹת עִם אֵלֶּה: הִגְדִּיל יְיָ לַעֲשׂוֹת עִמָּנוּ הָיִינוּ שְׂמֵחִים: שׁוּבָה יְיָ אֶת שְׁבִיתֵנוּ כַּאֲפִיקִים בַּנֶּגֶב: הַזֹּרְעִים בְּדִמְעָה בְּרִנָּה יִקְצֹרוּ: הָלוֹךְ יֵלֵךְ וּבָכֹה נֹשֵׂא מֶשֶׁךְ הַזָּרַע בֹּא יָבֹא בְרִנָּה נֹשֵׂא אֲלֻמֹתָיו:

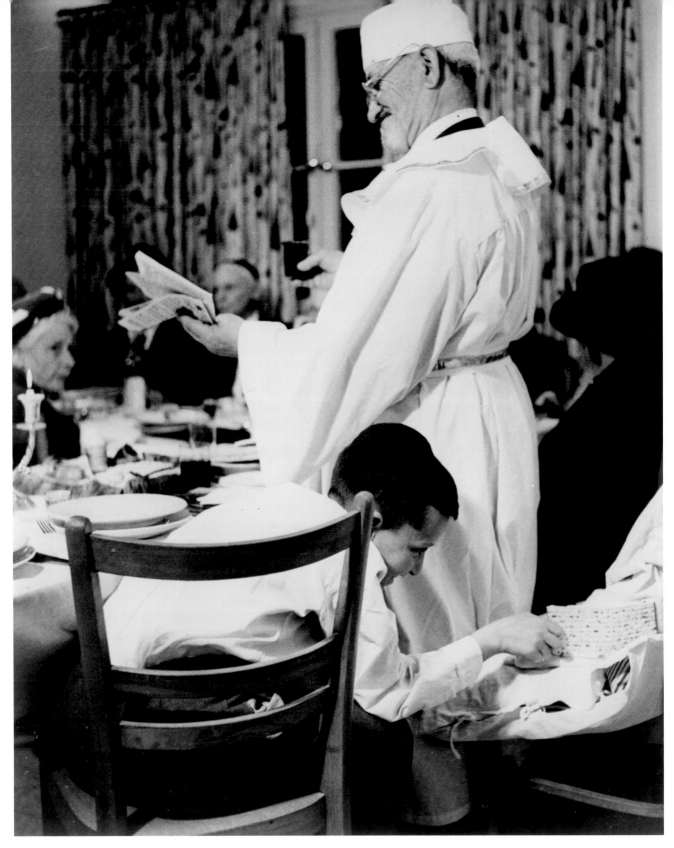

ABOVE:
Just the moment he was waiting for: "stealing" the Afikomen at a multigenerational *MALBEN* seder. *Israel, 1954.*

When three or more adults eat together, the following introduction is said; if there are 10 or more, the words in parentheses are added.

LEADER: Let us bless God!

PARTICIPANTS: May God's name be blessed now and forever!

LEADER: May God's name be blessed now and forever! With your approval, let us bless the One (our God) from whose food we have eaten!

PARTICIPANTS: Blessed is the One (our God) from whose food we have eaten and through whose goodness we live!

LEADER: Blessed is the One (our God) from whose food we have eaten and through whose goodness we live!

BLESSED IS GOD and blessed is God's name!

BLESSED ARE YOU, Lord our God, King of the universe, who sustains the entire world with kindness and compassion. "God gives bread to all; God's mercy endures forever" (Psalms 136:12). God's great goodness has never failed us, nor may it ever fail us, for God nourishes everyone and provides every creature with food. Blessed is God who provides food for all!

WE THANK GOD for the "land of milk and honey" given to our ancestors, and for freeing us from slavery in Egypt; for the sign of the covenant with Abraham, and for teaching us the Torah; for instructing us, for granting us the gift of life, and for providing us with food at all times.

FOR ALL THIS WE THANK and bless God; may God's name be blessed forever, as it is written in the Torah, "When you have eaten and are satisfied, you shall bless God for the good land given to you" (Deuteronomy 8:10). Blessed is God for the land and for our food!

הַמְזַמֵּן: רַבּוֹתַי נְבָרֵךְ!

הַמְסֻבִּין: יְהִי שֵׁם יְיָ מְבֹרָךְ מֵעַתָּה וְעַד עוֹלָם.

הַמְזַמֵּן: יְהִי שֵׁם יְיָ מְבֹרָךְ מֵעַתָּה וְעַד עוֹלָם. בִּרְשׁוּת מָרָנָן וְרַבָּנָן וְרַבּוֹתַי, נְבָרֵךְ (אֱלֹהֵינוּ) שֶׁאָכַלְנוּ מִשֶּׁלּוֹ.

הַמְסֻבִּין: בָּרוּךְ (אֱלֹהֵינוּ) שֶׁאָכַלְנוּ מִשֶּׁלּוֹ וּבְטוּבוֹ חָיִינוּ.

הַמְזַמֵּן: בָּרוּךְ (אֱלֹהֵינוּ) שֶׁאָכַלְנוּ מִשֶּׁלּוֹ וּבְטוּבוֹ חָיִינוּ.

בָּרוּךְ הוּא וּבָרוּךְ שְׁמוֹ:

בָּרוּךְ אַתָּה יְיָ, אֱלֹהֵינוּ מֶלֶךְ הָעוֹלָם, הַזָּן אֶת הָעוֹלָם כֻּלּוֹ בְּטוּבוֹ בְּחֵן בְּחֶסֶד וּבְרַחֲמִים. הוּא נוֹתֵן לֶחֶם לְכָל בָּשָׂר כִּי לְעוֹלָם חַסְדּוֹ. וּבְטוּבוֹ הַגָּדוֹל תָּמִיד לֹא חָסַר לָנוּ וְאַל יֶחְסַר לָנוּ מָזוֹן לְעוֹלָם וָעֶד. בַּעֲבוּר שְׁמוֹ הַגָּדוֹל. כִּי הוּא אֵל זָן וּמְפַרְנֵס לַכֹּל וּמֵטִיב לַכֹּל וּמֵכִין מָזוֹן לְכָל בְּרִיּוֹתָיו אֲשֶׁר בָּרָא. בָּרוּךְ אַתָּה יְיָ, הַזָּן אֶת הַכֹּל:

נוֹדֶה לְּךָ יְיָ אֱלֹהֵינוּ עַל שֶׁהִנְחַלְתָּ לַאֲבוֹתֵינוּ. אֶרֶץ חֶמְדָּה טוֹבָה וּרְחָבָה, וְעַל שֶׁהוֹצֵאתָנוּ יְיָ אֱלֹהֵינוּ מֵאֶרֶץ מִצְרַיִם, וּפְדִיתָנוּ. מִבֵּית עֲבָדִים, וְעַל בְּרִיתְךָ שֶׁחָתַמְתָּ בִּבְשָׂרֵנוּ. וְעַל תּוֹרָתְךָ שֶׁלִּמַּדְתָּנוּ. וְעַל חֻקֶּיךָ שֶׁהוֹדַעְתָּנוּ. וְעַל חַיִּים חֵן וָחֶסֶד שֶׁחוֹנַנְתָּנוּ. וְעַל אֲכִילַת מָזוֹן שָׁאַתָּה זָן וּמְפַרְנֵס אוֹתָנוּ תָּמִיד בְּכָל יוֹם וּבְכָל עֵת וּבְכָל שָׁעָה:

וְעַל הַכֹּל יְיָ אֱלֹהֵינוּ אֲנַחְנוּ מוֹדִים לָךְ, וּמְבָרְכִים אוֹתָךְ, יִתְבָּרַךְ שִׁמְךָ בְּפִי כָל חַי תָּמִיד לְעוֹלָם וָעֶד. כַּכָּתוּב. וְאָכַלְתָּ וְשָׂבָעְתָּ. וּבֵרַכְתָּ אֶת יְיָ אֱלֹהֶיךָ עַל הָאָרֶץ הַטֹּבָה אֲשֶׁר נָתַן לָךְ. בָּרוּךְ אַתָּה יְיָ, עַל הָאָרֶץ וְעַל הַמָּזוֹן:

MAY GOD HAVE MERCY on the people Israel, on Jerusalem, on Zion, on the royal house of David, and on the holy Temple! May God protect and feed us, support and maintain us, and help us out of all our troubles. May we never be dependent on others, but rely only upon God's help, thus sparing us shame and embarrassment.

On Shabbat, add:
MAY GOD STRENGTHEN US in keeping the commandments, especially the holy Shabbat, the great and holy seventh day. May this be a day of peaceful rest, free of all worry and sorrow. May God, who saves and comforts, enable us to see Zion comforted and Jerusalem rebuilt as a holy city!

MAY GOD REMEMBER US and our ancestors on this day of Pesach and grant us a life of happiness and blessing! May God grant us life and well-being, mercy and peace! We appeal to God who is always gracious and kind!

MAY GOD REBUILD JERUSALEM the holy city soon in our lifetime! Blessed is God who builds Jerusalem in mercy! Amen.

רַחֵם נָא יְיָ אֱלֹהֵינוּ, עַל יִשְׂרָאֵל עַמֶּךָ, וְעַל יְרוּשָׁלַיִם עִירֶךָ, וְעַל צִיּוֹן מִשְׁכַּן כְּבוֹדֶךָ, וְעַל מַלְכוּת בֵּית דָּוִד מְשִׁיחֶךָ, וְעַל הַבַּיִת הַגָּדוֹל וְהַקָּדוֹשׁ שֶׁנִּקְרָא שִׁמְךָ עָלָיו. אֱלֹהֵינוּ, אָבִינוּ, רְעֵנוּ, זוּנֵנוּ, פַּרְנְסֵנוּ, וְכַלְכְּלֵנוּ, וְהַרְוִיחֵנוּ, וְהַרְוַח לָנוּ יְיָ אֱלֹהֵינוּ מְהֵרָה מִכָּל צָרוֹתֵינוּ. וְנָא, אַל תַּצְרִיכֵנוּ יְיָ אֱלֹהֵינוּ, לֹא לִידֵי מַתְּנַת בָּשָׂר וָדָם, וְלֹא לִידֵי הַלְוָאָתָם. כִּי אִם לְיָדְךָ הַמְּלֵאָה, הַפְּתוּחָה, הַקְּדוֹשָׁה וְהָרְחָבָה, שֶׁלֹּא נֵבוֹשׁ וְלֹא נִכָּלֵם לְעוֹלָם וָעֶד:

לשבת רְצֵה וְהַחֲלִיצֵנוּ יְיָ אֱלֹהֵינוּ בְּמִצְוֹתֶיךָ וּבְמִצְוַת יוֹם הַשְּׁבִיעִי הַשַּׁבָּת הַגָּדוֹל וְהַקָּדוֹשׁ הַזֶּה. כִּי יוֹם זֶה גָּדוֹל וְקָדוֹשׁ הוּא לְפָנֶיךָ, לִשְׁבָּת בּוֹ וְלָנוּחַ בּוֹ בְּאַהֲבָה כְּמִצְוַת רְצוֹנֶךָ. וּבִרְצוֹנְךָ הָנִיחַ לָנוּ, יְיָ אֱלֹהֵינוּ. שֶׁלֹּא תְהֵא צָרָה וְיָגוֹן וַאֲנָחָה בְּיוֹם מְנוּחָתֵנוּ. וְהַרְאֵנוּ יְיָ אֱלֹהֵינוּ בְּנֶחָמַת צִיּוֹן עִירֶךָ, וּבְבִנְיַן יְרוּשָׁלַיִם עִיר קָדְשֶׁךָ, כִּי אַתָּה הוּא בַּעַל הַיְשׁוּעוֹת וּבַעַל הַנֶּחָמוֹת:

אֱלֹהֵינוּ וֵאלֹהֵי אֲבוֹתֵינוּ, יַעֲלֶה וְיָבֹא וְיַגִּיעַ, וְיֵרָאֶה, וְיֵרָצֶה, וְיִשָּׁמַע, וְיִפָּקֵד, וְיִזָּכֵר זִכְרוֹנֵנוּ וּפִקְדוֹנֵנוּ. וְזִכְרוֹן אֲבוֹתֵינוּ. וְזִכְרוֹן מָשִׁיחַ בֶּן דָּוִד עַבְדֶּךָ, וְזִכְרוֹן יְרוּשָׁלַיִם עִיר קָדְשֶׁךָ, וְזִכְרוֹן כָּל עַמְּךָ בֵּית יִשְׂרָאֵל לְפָנֶיךָ, לִפְלֵיטָה לְטוֹבָה לְחֵן וּלְחֶסֶד וּלְרַחֲמִים, לְחַיִּים וּלְשָׁלוֹם בְּיוֹם חַג הַמַּצּוֹת הַזֶּה. זָכְרֵנוּ יְיָ אֱלֹהֵינוּ בּוֹ לְטוֹבָה, וּפָקְדֵנוּ בוֹ לִבְרָכָה, וְהוֹשִׁיעֵנוּ בוֹ לְחַיִּים. וּבִדְבַר יְשׁוּעָה וְרַחֲמִים, חוּס וְחָנֵּנוּ, וְרַחֵם עָלֵינוּ וְהוֹשִׁיעֵנוּ, כִּי אֵלֶיךָ עֵינֵינוּ, כִּי אֵל מֶלֶךְ חַנּוּן וְרַחוּם אָתָּה:

וּבְנֵה יְרוּשָׁלַיִם עִיר הַקֹּדֶשׁ בִּמְהֵרָה בְיָמֵינוּ. בָּרוּךְ אַתָּה יְיָ, בּוֹנֵה בְרַחֲמָיו יְרוּשָׁלָיִם. אָמֵן:

BLESSED ARE YOU, Lord our God, King of the universe.
Blessed is God, our creator and redeemer,
who is good and does good to everyone,
and who is kind to us at all times!
May God ever grant us kindness and compassion,
prosperity and success, blessing and comfort, life and
peace! May we never lack the good things of life!

בָּרוּךְ אַתָּה יְיָ, אֱלֹהֵינוּ מֶלֶךְ הָעוֹלָם, הָאֵל
אָבִינוּ, מַלְכֵּנוּ, אַדִּירֵנוּ בּוֹרְאֵנוּ,
גּוֹאֲלֵנוּ, יוֹצְרֵנוּ, קְדוֹשֵׁנוּ קְדוֹשׁ יַעֲקֹב. רוֹעֵנוּ
רוֹעֵה יִשְׂרָאֵל. הַמֶּלֶךְ הַטּוֹב, וְהַמֵּטִיב לַכֹּל,
שֶׁבְּכָל יוֹם וָיוֹם הוּא הֵטִיב, הוּא מֵטִיב. הוּא
יֵיטִיב לָנוּ. הוּא גְמָלָנוּ, הוּא גוֹמְלֵנוּ, הוּא
יִגְמְלֵנוּ לָעַד לְחֵן וּלְחֶסֶד וּלְרַחֲמִים וּלְרֶוַח
הַצָּלָה וְהַצְלָחָה בְּרָכָה וִישׁוּעָה, נֶחָמָה, פַּרְנָסָה
וְכַלְכָּלָה, וְרַחֲמִים. וְחַיִּים וְשָׁלוֹם. וְכָל טוֹב.
וּמִכָּל טוּב לְעוֹלָם אַל יְחַסְּרֵנוּ:

MAY GOD reign over us forever!
May God be blessed in heaven and on earth!
May God be praised in every generation and
glorified through our lives forever more!
May God maintain us with honor!
May God break the yoke of our exile and lead us
upright to our land!
May God shower this house and this table
with blessings!
May God send us Elijah the prophet, who will bring
good news of the Messiah!

הָרַחֲמָן, הוּא יִמְלוֹךְ עָלֵינוּ לְעוֹלָם וָעֶד.
הָרַחֲמָן, הוּא יִתְבָּרַךְ בַּשָּׁמַיִם
וּבָאָרֶץ. הָרַחֲמָן, הוּא יִשְׁתַּבַּח לְדוֹר דּוֹרִים,
וְיִתְפָּאַר בָּנוּ לָעַד וּלְנֵצַח נְצָחִים, וְיִתְהַדַּר בָּנוּ
לָעַד וּלְעוֹלְמֵי עוֹלָמִים. הָרַחֲמָן, הוּא יְפַרְנְסֵנוּ
בְּכָבוֹד. הָרַחֲמָן, הוּא יִשְׁבּוֹר עֻלֵּנוּ מֵעַל צַוָּארֵנוּ
וְהוּא יוֹלִיכֵנוּ קוֹמְמִיּוּת לְאַרְצֵנוּ. הָרַחֲמָן,
הוּא יִשְׁלַח לָנוּ בְּרָכָה מְרֻבָּה בַּבַּיִת הַזֶּה, וְעַל
שֻׁלְחָן זֶה שֶׁאָכַלְנוּ עָלָיו. הָרַחֲמָן, הוּא יִשְׁלַח
לָנוּ אֶת אֵלִיָּהוּ הַנָּבִיא זָכוּר לַטּוֹב. וִיבַשֶּׂר לָנוּ
בְּשׂוֹרוֹת טוֹבוֹת יְשׁוּעוֹת וְנֶחָמוֹת.

MAY GOD BLESS
(my parents) the heads of this household/all who are
seated at this table and their families;
just as our ancestors were blessed with everything,
so may we be blessed! Amen.

הָרַחֲמָן, הוּא יְבָרֵךְ:

אוֹתִי וְאֶת כָּל | אֶת (אָבִי מוֹרִי) בַּעַל הַבַּיִת
אֲשֶׁר לִי. | הַזֶּה, וְאֶת (אִמִּי מוֹרָתִי) בַּעֲלַת
 | הַבַּיִת הַזֶּה, אוֹתָם וְאֶת בֵּיתָם
 | וְאֶת זַרְעָם וְאֶת כָּל אֲשֶׁר לָהֶם.

אוֹתָנוּ וְאֶת כָּל אֲשֶׁר לָנוּ, כְּמוֹ שֶׁנִּתְבָּרְכוּ
אֲבוֹתֵינוּ. אַבְרָהָם יִצְחָק וְיַעֲקֹב.
בַּכֹּל, מִכֹּל, כֹּל. כֵּן יְבָרֵךְ אוֹתָנוּ כֻּלָּנוּ יַחַד.
בִּבְרָכָה שְׁלֵמָה, וְנֹאמַר אָמֵן:

MAY GOD grant us eternal reward, and may we merit God's blessing! May we always find favor in the eyes of both God and our fellow creatures!

בַּמָּרוֹם יְלַמְּדוּ עֲלֵיהֶם וְעָלֵינוּ זְכוּת, שֶׁתְּהֵא לְמִשְׁמֶרֶת שָׁלוֹם, וְנִשָּׂא בְרָכָה מֵאֵת יְיָ וּצְדָקָה מֵאֱלֹהֵי יִשְׁעֵנוּ, וְנִמְצָא חֵן וְשֵׂכֶל טוֹב בְּעֵינֵי אֱלֹהִים וְאָדָם:

On Shabbat, add:
MAY GOD grant us a day of complete rest, a taste of the world-to-come.

לשבת
הָרַחֲמָן, הוּא יַנְחִילֵנוּ יוֹם שֶׁכֻּלּוֹ שַׁבָּת וּמְנוּחָה לְחַיֵּי הָעוֹלָמִים.

MAY GOD grant us a day that will be entirely festive!

הָרַחֲמָן, הוּא יַנְחִילֵנוּ יוֹם שֶׁכֻּלּוֹ טוֹב.

MAY GOD make us worthy to enjoy the time of the Messiah and the life of the world-to-come! "God is a tower of strength to the king, forever showing kindness to the royal house of David." (II Samuel 22:51). May God who makes peace in the heavens make peace among us and all Israel! Amen.

הָרַחֲמָן, הוּא יְזַכֵּנוּ לִימוֹת הַמָּשִׁיחַ וּלְחַיֵּי הָעוֹלָם הַבָּא. מִגְדּוֹל יְשׁוּעוֹת מַלְכּוֹ, וְעֹשֶׂה חֶסֶד לִמְשִׁיחוֹ לְדָוִד וּלְזַרְעוֹ עַד עוֹלָם: עֹשֶׂה שָׁלוֹם בִּמְרוֹמָיו, הוּא יַעֲשֶׂה שָׁלוֹם, עָלֵינוּ וְעַל כָּל יִשְׂרָאֵל, וְאִמְרוּ אָמֵן:

"MAY WE BECOME holy by revering God and never know want! Scoffers may go hungry, but those who seek God will not lack anything" (Psalms 34:9-10). "Give thanks to God, whose kindness lasts forever" (Psalms 118:1). "God generously satisfies every living thing" (Psalms 145:16). "Blessed are those who trust in God, making God their trust" (Psalms 40:4). "I was young and now I am old, but I have not seen the righteous forsaken, nor their children begging for bread" (Psalms 37:25). "May God grant strength to Israel! May God bless us with peace!" (Psalms 29:11)

יְראוּ אֶת יְיָ קְדֹשָׁיו, כִּי אֵין מַחְסוֹר לִירֵאָיו: כְּפִירִים רָשׁוּ וְרָעֵבוּ, וְדֹרְשֵׁי יְיָ לֹא יַחְסְרוּ כָל טוֹב: הוֹדוּ לַיְיָ כִּי טוֹב, כִּי לְעוֹלָם חַסְדּוֹ: פּוֹתֵחַ אֶת יָדֶךָ, וּמַשְׂבִּיעַ לְכָל חַי רָצוֹן: בָּרוּךְ הַגֶּבֶר אֲשֶׁר יִבְטַח בַּיְיָ, וְהָיָה יְיָ מִבְטַחוֹ: נַעַר הָיִיתִי גַם זָקַנְתִּי וְלֹא רָאִיתִי צַדִּיק נֶעֱזָב, וְזַרְעוֹ מְבַקֶּשׁ לָחֶם: יְיָ עֹז לְעַמּוֹ יִתֵּן, יְיָ יְבָרֵךְ אֶת עַמּוֹ בַשָּׁלוֹם:

Lift the wine cup and recite:
BLESSED ARE YOU, Lord our God,
King of the universe, who creates the fruit of the vine.

בָּרוּךְ אַתָּה יְיָ, אֱלֹהֵינוּ מֶלֶךְ הָעוֹלָם, בּוֹרֵא פְּרִי הַגָּפֶן:

*Barukh atah Adonai, Eloheinu melekh ha-olam,
borei pri hagafen.*

*Drink the third cup of wine while reclining to the left.
Pour the fourth cup of wine and fill the Cup of Elijah.*

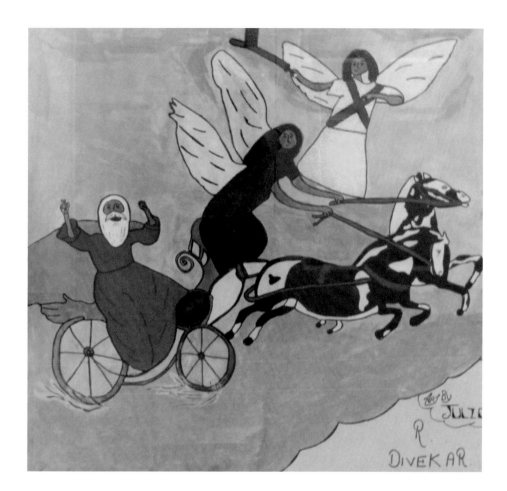

ELIJAH

The door is opened; all rise to say:

POUR OUT Your anger on the nations who do not know You, and on the kingdoms who have not called on Your name, for they have attacked Jacob and destroyed his dwelling place. Pour out Your fury on them; let Your fierce anger overtake them. Pursue them in anger and destroy them from under God's heavens."

Close the door. All are seated.

שְׁפֹךְ חֲמָתְךָ אֶל־הַגּוֹיִם, אֲשֶׁר לֹא יְדָעוּךָ
וְעַל־מַמְלָכוֹת אֲשֶׁר בְּשִׁמְךָ לֹא קָרָאוּ:
כִּי אָכַל אֶת־יַעֲקֹב. וְאֶת־נָוֵהוּ הֵשַׁמּוּ:
שְׁפָךְ־עֲלֵיהֶם זַעְמֶךָ, וַחֲרוֹן אַפְּךָ יַשִּׂיגֵם:
תִּרְדֹּף בְּאַף וְתַשְׁמִידֵם, מִתַּחַת שְׁמֵי יְיָ:

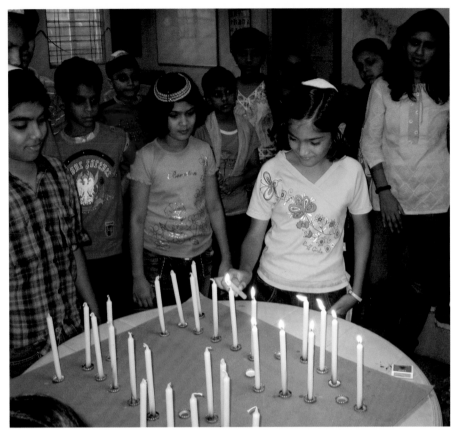

LEFT:
With the aid of JDC Jewish Service Corps volunteers, Jewish youth enjoy a variety of activities and holiday celebrations at the Evelyn Peters Jewish Community Center in Mumbai. *India, 2008.*
OPPOSITE PAGE:
This drawing of Elijah's ascent to heaven won a children's drawing contest in India sponsored by JDC.

ON THIS NIGHT OF REDEMPTION, Jews recognize that our salvation is not complete. We may experience freedom and a sense of community, but others remain enslaved, impoverished and bereft of the people and places they love. We hope for a better future for all, a message best embodied in Elijah the Prophet, who is the herald of the ultimate redemption. At this point in the seder, we rise, open the door to our homes and invite in Elijah. We are so confident of his arrival that we set a special cup of wine in the center of the table for him.

There is a beautiful Hasidic custom that encourages everyone gathered around the seder table to add some wine to Elijah's cup. Everyone has something to contribute, a reminder that the work of human redemption is a collective effort. We cannot wait for miracles or supernatural forces but have to take the first steps ourselves. Drop by drop we fill the cup of redemption.

Elijah is no stranger in Jewish homes. Whether we see him or not, we make room for him at every *bris* ceremony that brings a Jewish infant boy into the Covenant of Abraham. We even prepare a special chair for Elijah's arrival. We also invoke Elijah at the *havdalah* ceremony that separates Shabbat and the rest of the week. "Elijah, the Prophet," we sing. "May he come soon to us in our day." To wish for Elijah is to wish for a better tomorrow.

There is no Jewish community more devoted to Elijah than the Bene Israel Jews of India. In the homes of many Bene Israel there is a picture of Elijah ascending to heaven in a fiery horse-drawn chariot. According to Bene Israel legend, Elijah had visited the isolated community of Indian Jews in times of need, including once to revive the original settlers who had drowned at sea. The Bene Israel revere a piece of land in the western Indian city of Khandala where they say one can still see the footprint of Elijah as he ascended to heaven.

After the establishment of the State of Israel in 1948, the vast majority of the Jews of India left for Israel. They have integrated well into Israeli society, but many still keep the customs of their homeland and hang a picture of Elijah on their wall.

HALLEL

<div dir="rtl">

הַלֵּל

</div>

The songs of praise chanted before the meal are now continued:

GIVE GLORY NOT TO US, God, but to Your name, for the sake of Your kindness and truth. Why should the nations say, "Where is their God now?" While our God is in heaven, fulfilling the divine will. Their idols are silver and gold, merely mortal handiwork! Their idols have mouths, but they cannot speak; eyes, but they cannot see; they have ears, but cannot hear; noses, but they cannot smell; they have hands, but cannot touch; feet, but they cannot walk; they cannot make any sound in their throats! Those who make them — those that trust in them — shall be like them! Israel, trust in God, our help and shield! House of Aaron, trust in God, our help and shield! All who revere God, trust in God, our help and shield!

<div dir="rtl">

לֹא לָנוּ יְיָ לֹא לָנוּ כִּי לְשִׁמְךָ תֵּן כָּבוֹד, עַל חַסְדְּךָ עַל אֲמִתֶּךָ. לָמָּה יֹאמְרוּ הַגּוֹיִם. אַיֵּה נָא אֱלֹהֵיהֶם. וֵאלֹהֵינוּ בַשָּׁמָיִם, כֹּל אֲשֶׁר חָפֵץ עָשָׂה. עֲצַבֵּיהֶם כֶּסֶף וְזָהָב. מַעֲשֵׂה יְדֵי אָדָם. פֶּה לָהֶם וְלֹא יְדַבֵּרוּ, עֵינַיִם לָהֶם וְלֹא יִרְאוּ. אָזְנַיִם לָהֶם וְלֹא יִשְׁמָעוּ, אַף לָהֶם וְלֹא יְרִיחוּן. יְדֵיהֶם וְלֹא יְמִישׁוּן, רַגְלֵיהֶם וְלֹא יְהַלֵּכוּ, לֹא יֶהְגּוּ בִּגְרוֹנָם. כְּמוֹהֶם יִהְיוּ עֹשֵׂיהֶם. כֹּל אֲשֶׁר בֹּטֵחַ בָּהֶם: יִשְׂרָאֵל בְּטַח בַּיְיָ, עֶזְרָם וּמָגִנָּם הוּא. בֵּית אַהֲרֹן בִּטְחוּ בַיְיָ, עֶזְרָם וּמָגִנָּם הוּא. יִרְאֵי יְיָ בִּטְחוּ בַיְיָ, עֶזְרָם וּמָגִנָּם הוּא:

</div>

MAY GOD, Who has remembered us, bless us! May God bless the House of Israel! May God bless the House of Aaron! May God bless all those who revere God, great and small alike! Make God increase your numbers and those of your children! May you be blessed by God, creator of heaven and earth! The heavens belong to God, but the earth has been given to us [to use as God directs]. The dead cannot praise God, nor any who go down in silence, But we will praise God now and forever! Hallelujah!

<div dir="rtl">

יְיָ זְכָרָנוּ יְבָרֵךְ, יְבָרֵךְ אֶת בֵּית יִשְׂרָאֵל, יְבָרֵךְ אֶת בֵּית אַהֲרֹן. יְבָרֵךְ יִרְאֵי יְיָ, הַקְּטַנִּים עִם הַגְּדֹלִים. יֹסֵף יְיָ עֲלֵיכֶם, עֲלֵיכֶם וְעַל בְּנֵיכֶם. בְּרוּכִים אַתֶּם לַיְיָ, עֹשֵׂה שָׁמַיִם וָאָרֶץ. הַשָּׁמַיִם שָׁמַיִם לַיְיָ, וְהָאָרֶץ נָתַן לִבְנֵי אָדָם. לֹא הַמֵּתִים יְהַלְלוּ יָהּ, וְלֹא כָּל יֹרְדֵי דוּמָה. וַאֲנַחְנוּ נְבָרֵךְ יָהּ, מֵעַתָּה וְעַד עוֹלָם, הַלְלוּיָהּ:

</div>

I LOVE IT when God listens to my pleas for help, for God answers me whenever I call. The bonds of death encircled me, mortal pangs took hold of me — I found nothing but trouble and sorrow. Then I called upon God: "God, save my life!" God is merciful and just; God is compassionate. God protects the simple; I was low, and God saved me. I can breathe now, for God has been good to me. God saved me from death; God kept me from crying and stumbling. I shall walk before God in the land of the living. Even when I said, "I am sorely troubled," I believed in God; even when I said, "Everyone is false."

<div dir="rtl">

אָהַבְתִּי כִּי יִשְׁמַע יְיָ, אֶת קוֹלִי תַּחֲנוּנָי. כִּי הִטָּה אָזְנוֹ לִי וּבְיָמַי אֶקְרָא. אֲפָפוּנִי חֶבְלֵי מָוֶת, וּמְצָרֵי שְׁאוֹל מְצָאוּנִי, צָרָה וְיָגוֹן אֶמְצָא. וּבְשֵׁם יְיָ אֶקְרָא, אָנָּה יְיָ מַלְּטָה נַפְשִׁי. חַנּוּן יְיָ וְצַדִּיק, וֵאלֹהֵינוּ מְרַחֵם. שֹׁמֵר פְּתָאיִם יְיָ, דַּלּוֹתִי וְלִי יְהוֹשִׁיעַ. שׁוּבִי נַפְשִׁי לִמְנוּחָיְכִי, כִּי יְיָ גָּמַל עָלָיְכִי. כִּי חִלַּצְתָּ נַפְשִׁי מִמָּוֶת, אֶת עֵינִי מִן דִּמְעָה, אֶת רַגְלִי מִדֶּחִי. אֶתְהַלֵּךְ לִפְנֵי יְיָ, בְּאַרְצוֹת הַחַיִּים. הֶאֱמַנְתִּי כִּי אֲדַבֵּר, אֲנִי עָנִיתִי מְאֹד. אֲנִי אָמַרְתִּי בְחָפְזִי, כָּל הָאָדָם כֹּזֵב.

</div>

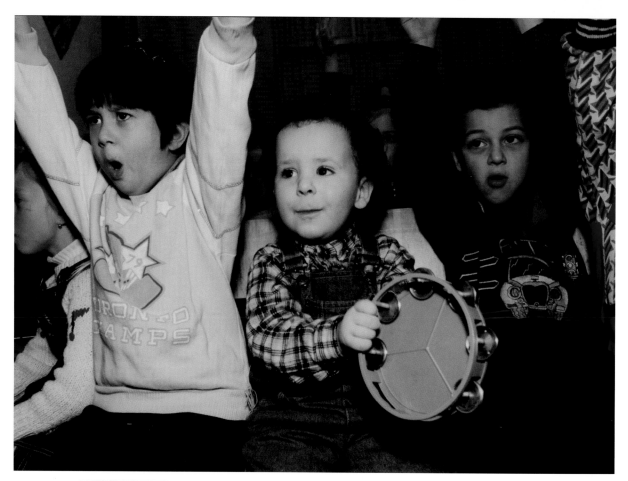

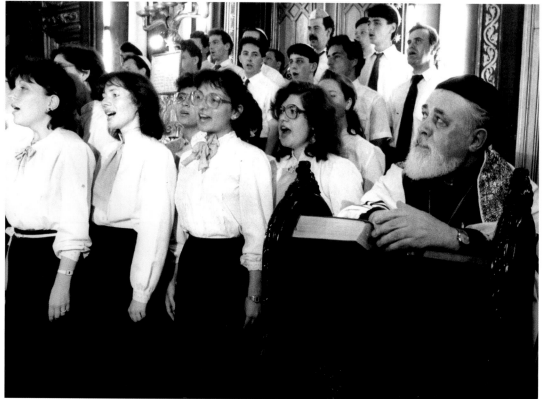

ABOVE:
Enthusiastic youngsters at a Jewish community center music class in Odessa. *Ukraine, 1999.*
Photo: Roy Mittelman

RIGHT:
Rabbi Moses Rosen, Chief Rabbi of Romania from 1948 to 1994, listens to one of the many choirs he established in his creative effort to maintain Jewish religious, cultural, and educational traditions in the face of Communist-era restrictions. *Romania, 1988.* Photo: Edward Serotta

HOW CAN I REPAY GOD for all the goodness I have received? I shall lift the cup of salvation and call upon God's name! I shall fulfill my vows to God in the presence of the entire people! Grievous in God's sight is the death of the faithful! O God, I am Your servant, born to serve You; You have undone the bonds that held me. I shall make an offering of thanksgiving and call upon Your name! I shall fulfill my vows to God in the presence of the entire people, in the courts of the Temple, in the midst of Jerusalem. Hallelujah!

LET ALL THE NATIONS praise God!
Let all peoples extol God, for God's love for us is great; God's faithfulness lasts forever. Hallelujah!

GIVE THANKS TO GOD, who is good, whose lovingkindness lasts forever! Let all Israel declare, "God's lovingkindness lasts forever!"
Let the House of Aaron declare, "God's lovingkindness lasts forever!" Let all who revere God declare, "God's lovingkindness lasts forever!"

IN MY DISTRESS I called upon God, who answered me and helped me out. God is with me, I shall not fear; what can human beings do to me? God is with me as my helper; I shall see my enemies' downfall. It is better to take refuge in God than to trust in mortals; It is better to take refuge in God than to trust in the powerful. All the nations encircled me, but with God's help I overcame them. They encircled me and surrounded me, but with God's help I overcame them. They encircled me like bees, but they were extinguished like a thornbush fire, for God helped me overcome them. My enemies pushed me, to make me fall, but God helped me up. God is my strength and might; God is my salvation! Listen! Joy and salvation in the tents of the righteous! God's right hand is triumphant! God's right hand is held high, God's right hand is triumphant!

I SHALL NOT DIE, but live and tell of God's wondrous acts. God has sorely tried me, but has not handed me over to death! Open to me the gates of righteousness, that I may enter and praise God! This is the gate of God; the righteous shall enter it. I thank God who has answered me and become my salvation! The stone which the builders rejected has become the chief cornerstone. This is God's doing; it is marvelous in our eyes. This is the day that God has made; let us be joyful and glad on it!

מָה אָשִׁיב לַייָ, כָּל תַּגְמוּלוֹהִי עָלָי. כּוֹס יְשׁוּעוֹת אֶשָּׂא, וּבְשֵׁם יְיָ אֶקְרָא. נְדָרַי לַייָ אֲשַׁלֵּם, נֶגְדָה נָּא לְכָל עַמּוֹ. יָקָר בְּעֵינֵי יְיָ הַמָּוְתָה לַחֲסִידָיו. אָנָּה יְיָ כִּי אֲנִי עַבְדֶּךָ, אֲנִי עַבְדְּךָ בֶּן אֲמָתֶךָ, פִּתַּחְתָּ לְמוֹסֵרָי. לְךָ אֶזְבַּח זֶבַח תּוֹדָה וּבְשֵׁם יְיָ אֶקְרָא. נְדָרַי לַייָ אֲשַׁלֵּם, נֶגְדָה נָּא לְכָל עַמּוֹ. בְּחַצְרוֹת בֵּית יְיָ בְּתוֹכֵכִי יְרוּשָׁלָיִם הַלְלוּיָהּ.

הַלְלוּ אֶת יְיָ, כָּל גּוֹיִם, שַׁבְּחוּהוּ כָּל הָאֻמִּים. כִּי גָבַר עָלֵינוּ חַסְדּוֹ, וֶאֱמֶת יְיָ לְעוֹלָם הַלְלוּיָהּ:

הוֹדוּ לַייָ כִּי טוֹב, כִּי לְעוֹלָם חַסְדּוֹ: יֹאמַר נָא יִשְׂרָאֵל, כִּי לְעוֹלָם חַסְדּוֹ: יֹאמְרוּ נָא בֵית אַהֲרֹן, כִּי לְעוֹלָם חַסְדּוֹ: יֹאמְרוּ נָא יִרְאֵי יְיָ, כִּי לְעוֹלָם חַסְדּוֹ:

מִן הַמֵּצַר קָרָאתִי יָּהּ, עָנָנִי בַמֶּרְחָב יָהּ. יְיָ לִי לֹא אִירָא, מַה יַּעֲשֶׂה לִי אָדָם. יְיָ לִי בְּעֹזְרָי, וַאֲנִי אֶרְאֶה בְשֹׂנְאָי. טוֹב לַחֲסוֹת בַּייָ, מִבְּטֹחַ בָּאָדָם. טוֹב לַחֲסוֹת בַּייָ מִבְּטֹחַ בִּנְדִיבִים. כָּל גּוֹיִם סְבָבוּנִי בְּשֵׁם יְיָ כִּי אֲמִילַם. סַבּוּנִי גַם סְבָבוּנִי בְּשֵׁם יְיָ כִּי אֲמִילַם. סַבּוּנִי כִדְבֹרִים דֹּעֲכוּ כְּאֵשׁ קוֹצִים, בְּשֵׁם יְיָ כִּי אֲמִילַם. דָּחֹה דְחִיתַנִי לִנְפֹּל, וַיְיָ עֲזָרָנִי. עָזִּי וְזִמְרָת יָהּ, וַיְהִי לִי לִישׁוּעָה. קוֹל רִנָּה וִישׁוּעָה בְּאָהֳלֵי צַדִּיקִים, יְמִין יְיָ עֹשָׂה חָיִל. יְמִין יְיָ רוֹמֵמָה, יְמִין יְיָ עֹשָׂה חָיִל.

לֹא אָמוּת כִּי אֶחְיֶה, וַאֲסַפֵּר מַעֲשֵׂי יָהּ. יַסֹּר יִסְּרַנִי יָּהּ, וְלַמָּוֶת לֹא נְתָנָנִי. פִּתְחוּ לִי שַׁעֲרֵי צֶדֶק, אָבֹא בָם אוֹדֶה יָהּ. זֶה הַשַּׁעַר לַייָ, צַדִּיקִים יָבֹאוּ בוֹ. אוֹדְךָ כִּי עֲנִיתָנִי, וַתְּהִי לִי לִישׁוּעָה. (אוֹדְךָ) אֶבֶן מָאֲסוּ הַבּוֹנִים, הָיְתָה לְרֹאשׁ פִּנָּה. (אֶבֶן) מֵאֵת יְיָ הָיְתָה זֹּאת, הִיא נִפְלָאת בְּעֵינֵינוּ: (מֵאֵת) זֶה הַיּוֹם עָשָׂה יְיָ, נָגִילָה וְנִשְׂמְחָה בוֹ. (זֶה)

PLEASE GOD, SAVE US!
Please God, grant us success!

<div dir="rtl">

אָנָּא יְיָ הוֹשִׁיעָה נָּא:

אָנָּא יְיָ הוֹשִׁיעָה נָּא:

אָנָּא יְיָ הַצְלִיחָה נָּא:

אָנָּא יְיָ הַצְלִיחָה נָּא:

</div>

BLESSED ARE THEY who enter in the name of God; we bless you from the House of God! God has given us light; bind the festal offering to the horns of the altar with cords! You are my God, and I will thank You; You are my God, and I will extol You! Give thanks to God, who is good, whose lovingkindess lasts forever!

<div dir="rtl">

בָּרוּךְ הַבָּא בְּשֵׁם יְיָ, בֵּרַכְנוּכֶם מִבֵּית יְיָ. (בָּרוּךְ)
אֵל יְיָ וַיָּאֶר לָנוּ, אִסְרוּ חַג בַּעֲבֹתִים עַד
קַרְנוֹת הַמִּזְבֵּחַ. (אֵל)
אֵלִי אַתָּה וְאוֹדֶךָּ אֱלֹהַי אֲרוֹמְמֶךָּ. (אֵלִי)
הוֹדוּ לַיְיָ כִּי טוֹב. כִּי לְעוֹלָם חַסְדּוֹ: (הוֹדוּ)

</div>

MAY ALL YOUR CREATURES praise you, God, and may the pious, the just who do Your will, and the entire house of Israel thank and bless you with ringing song. All thanks are due to You, and it is appropriate to sing Your praises, everlasting God!

<div dir="rtl">

יְהַלְלוּךָ יְיָ אֱלֹהֵינוּ כָּל מַעֲשֶׂיךָ, וַחֲסִידֶיךָ
צַדִּיקִים עוֹשֵׂי רְצוֹנֶךָ, וְכָל עַמְּךָ
בֵּית יִשְׂרָאֵל בְּרִנָּה יוֹדוּ וִיבָרְכוּ וִישַׁבְּחוּ
וִיפָאֲרוּ וִירוֹמְמוּ וְיַעֲרִיצוּ וְיַקְדִּישׁוּ וְיַמְלִיכוּ אֶת
שִׁמְךָ מַלְכֵּנוּ, כִּי לְךָ טוֹב לְהוֹדוֹת וּלְשִׁמְךָ נָאֶה
לְזַמֵּר, כִּי מֵעוֹלָם וְעַד עוֹלָם אַתָּה אֵל.

</div>

Give thanks to God, who is good, whose lovingkindness lasts forever!

<div dir="rtl">

הוֹדוּ לַיְיָ כִּי טוֹב,

כִּי לְעוֹלָם חַסְדּוֹ:

</div>

Give thanks to the God of justice, whose lovingkindness lasts forever!

<div dir="rtl">

הוֹדוּ לֵאלֹהֵי הָאֱלֹהִים.

כִּי לְעוֹלָם חַסְדּוֹ:

</div>

Give thanks to the God of mercy, whose lovingkindness lasts forever!

<div dir="rtl">

הוֹדוּ לַאֲדֹנֵי הָאֲדֹנִים.

כִּי לְעוֹלָם חַסְדּוֹ:

</div>

Who alone does great wonders, whose lovingkindness lasts forever!

<div dir="rtl">

לְעֹשֵׂה נִפְלָאוֹת גְּדֹלוֹת לְבַדּוֹ.

כִּי לְעוֹלָם חַסְדּוֹ:

</div>

Who created the heavens in wisdom, whose lovingkindness lasts forever!

<div dir="rtl">

לְעֹשֵׂה הַשָּׁמַיִם בִּתְבוּנָה,

כִּי לְעוֹלָם חַסְדּוֹ:

</div>

Who spread the earth over the waters, whose lovingkindness lasts forever!

<div dir="rtl">

לְרוֹקַע הָאָרֶץ עַל הַמָּיִם,

כִּי לְעוֹלָם חַסְדּוֹ:

</div>

Who created the luminaries, whose lovingkindness lasts forever!

<div dir="rtl">

לְעֹשֵׂה אוֹרִים גְּדֹלִים,

כִּי לְעוֹלָם חַסְדּוֹ:

</div>

The sun to rule by day, whose lovingkindness lasts forever!

<div dir="rtl">

אֶת הַשֶּׁמֶשׁ לְמֶמְשֶׁלֶת בַּיּוֹם,

כִּי לְעוֹלָם חַסְדּוֹ:

</div>

The moon and stars to rule by night, whose lovingkindness lasts forever!	אֶת הַיָּרֵחַ וְכוֹכָבִים לְמֶמְשְׁלוֹת בַּלָּיְלָה, כִּי לְעוֹלָם חַסְדּוֹ:
Who struck the first-born of Egypt, whose lovingkindness lasts forever!	לְמַכֵּה מִצְרַיִם בִּבְכוֹרֵיהֶם, כִּי לְעוֹלָם חַסְדּוֹ:
Who led Israel from their midst, whose lovingkindness lasts forever!	וַיּוֹצֵא יִשְׂרָאֵל מִתּוֹכָם, כִּי לְעוֹלָם חַסְדּוֹ:
With a strong hand and an outstretched arm, whose lovingkindness lasts forever!	בְּיָד חֲזָקָה וּבִזְרוֹעַ נְטוּיָה, כִּי לְעוֹלָם חַסְדּוֹ:
Who split the Sea of Reeds in two, whose lovingkindness lasts forever!	לְגֹזֵר יַם סוּף לִגְזָרִים, כִּי לְעוֹלָם חַסְדּוֹ:
And led Israel through it, whose lovingkindness lasts forever!	וְהֶעֱבִיר יִשְׂרָאֵל בְּתוֹכוֹ, כִּי לְעוֹלָם חַסְדּוֹ:
But hurled Pharaoh and his army into the Sea, whose lovingkindness lasts forever!	וְנִעֵר פַּרְעֹה וְחֵילוֹ בְיַם סוּף, כִּי לְעוֹלָם חַסְדּוֹ:
Who led Israel through the wilderness, whose lovingkindness lasts forever!	לְמוֹלִיךְ עַמּוֹ בַּמִּדְבָּר, כִּי לְעוֹלָם חַסְדּוֹ:
Who defeated powerful kings, whose lovingkindness lasts forever!	לְמַכֵּה מְלָכִים גְּדֹלִים, כִּי לְעוֹלָם חַסְדּוֹ:
And slew mighty monarchs, whose lovingkindness lasts forever!	וַיַּהֲרֹג מְלָכִים אַדִּירִים, כִּי לְעוֹלָם חַסְדּוֹ:
Sihon, king of the Amorites, whose lovingkindness lasts forever!	לְסִיחוֹן מֶלֶךְ הָאֱמֹרִי, כִּי לְעוֹלָם חַסְדּוֹ:
And Og, king of Bashan, whose lovingkindness lasts forever!	וּלְעוֹג מֶלֶךְ הַבָּשָׁן, כִּי לְעוֹלָם חַסְדּוֹ:
And gave their land as an inheritance, whose lovingkindness lasts forever!	וְנָתַן אַרְצָם לְנַחֲלָה, כִּי לְעוֹלָם חַסְדּוֹ:
An inheritance to the people Israel, whose lovingkindness lasts forever!	נַחֲלָה לְיִשְׂרָאֵל עַבְדּוֹ, כִּי לְעוֹלָם חַסְדּוֹ:
Who remembered us in our distress, whose lovingkindness lasts forever!	שֶׁבְּשִׁפְלֵנוּ זָכַר לָנוּ, כִּי לְעוֹלָם חַסְדּוֹ:
And freed us from our foes, whose lovingkindness lasts forever!	וַיִּפְרְקֵנוּ מִצָּרֵינוּ, כִּי לְעוֹלָם חַסְדּוֹ:
Who gives food to all creatures, whose lovingkindness lasts forever!	נוֹתֵן לֶחֶם לְכָל בָּשָׂר, כִּי לְעוֹלָם חַסְדּוֹ:
Give thanks to God in heaven, whose lovingkindness lasts forever!	הוֹדוּ לְאֵל הַשָּׁמָיִם, כִּי לְעוֹלָם חַסְדּוֹ:

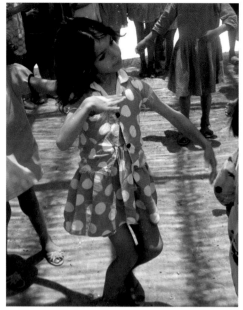

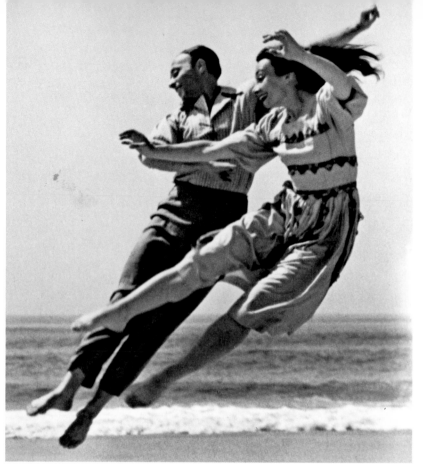

ABOVE:
Young girl dancing at a school in Tehran.
Iran, 1970s.
RIGHT:
Katya Delakova and Fred Berk pose on the beach
prior to leaving for Germany, where they brought
their "Dances of Palestine" program to those still
living in Displaced Persons camps. *Israel, 1948.*

IF THE FIRST HALF OF THE HAGGADAH is taken up with the telling
of the story of the Exodus, the second half is about thanking God for
our deliverance. We express our thanks in hymns of praise and joyous
song. The first part of this praise cycle is known as the Egyptian Hallel,
since it deals primarily with the Exodus, and the second part is known
as the Great Hallel, with the refrain "For His Mercy endures forever."

There is a curious passage in the Talmud about Hallel in which
Rabbi Yose proclaims: "May my portion be with those who
complete Hallel every day." Why, one wonders, would Rabbi Yose
wish to recite the festival liturgy on ordinary days? Isn't this just for
special occasions?

Perhaps Rabbi Yose understood that miracles of deliverance, both
big and small, are with us daily. In the accompanying pictures, see
the face of Henryk Kaston, a musician and refugee from Poland
who arrived in New York harbor in 1941, with his wife Marie and
their eight-day-old son Jose. They were among 735 refugees who
arrived on the Portuguese liner Mouzinho. Jose was born during
the journey.

See Fred Berk and his wife, Katya Delakova, leap into the air on a
Mediterranean beach. Berk was one of the fathers of modern Israeli
dance, both in Israel and the United States. And see the joy on the
face of a little girl in a polka dotted dress in a Jewish school in 1970
in Tehran.

Who can deny that miracles of deliverance happen every day?
Let us give praise.

BELOW:
Henryk Kaston serenades his wife and new son, born aboard the
Portuguese liner *Mouzinho* as it carried 735 refugees from Hitler's
Europe to safety in the West. United States, 1941.

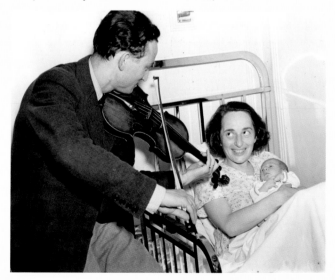

EVERYTHING THAT LIVES shall bless You,
God, and everyone shall praise You forever.
You are God without beginning and end.
We have no one else to redeem and save us,
nor to deliver us from every trouble and stress.
You are God of all creatures in every generation,
guiding the world in lovingkindness and mercy.
God does not slumber or sleep; God awakens the
sleepers, frees the fettered and supports the weak,
lifting those who are bowed low.
To You alone do we give thanks!

נִשְׁמַת כָּל חַי, תְּבָרֵךְ אֶת שִׁמְךָ יְיָ אֱלֹהֵינוּ.
וְרוּחַ כָּל בָּשָׂר, תְּפָאֵר וּתְרוֹמֵם זִכְרְךָ
מַלְכֵּנוּ תָּמִיד. מִן הָעוֹלָם וְעַד הָעוֹלָם אַתָּה
אֵל. וּמִבַּלְעָדֶיךָ אֵין לָנוּ מֶלֶךְ גּוֹאֵל וּמוֹשִׁיעַ.
פּוֹדֶה וּמַצִּיל וּמְפַרְנֵס וּמְרַחֵם. בְּכָל עֵת צָרָה
וְצוּקָה. אֵין לָנוּ מֶלֶךְ אֶלָּא אָתָּה: אֱלֹהֵי
הָרִאשׁוֹנִים וְהָאַחֲרוֹנִים, אֱלוֹהַּ כָּל בְּרִיּוֹת, אֲדוֹן
כָּל תּוֹלָדוֹת הַמְהֻלָּל בְּרֹב הַתִּשְׁבָּחוֹת, הַמְנַהֵג
עוֹלָמוֹ בְּחֶסֶד, וּבְרִיּוֹתָיו בְּרַחֲמִים. וַיְיָ לֹא
יָנוּם וְלֹא יִישָׁן, הַמְעוֹרֵר יְשֵׁנִים וְהַמֵּקִיץ נִרְדָּמִים.
וְהַמֵּשִׂיחַ אִלְּמִים, וְהַמַּתִּיר אֲסוּרִים, וְהַסּוֹמֵךְ
נוֹפְלִים, וְהַזּוֹקֵף כְּפוּפִים, לְךָ לְבַדְּךָ אֲנַחְנוּ מוֹדִים.

EVEN IF OUR MOUTHS WERE AS FULL of
song as the sea is full of water, and our tongues as
joyful as the waves roll in the ocean, our lips as full
of praise as the heavens stretch over the skies,
and our eyes as bright as the brilliance of the sun and
moon, our hands as outstretched as the wings of an
eagle, and our feet as swift as those of a deer,
we would still be unable to express enough thanks
for one ten-thousandth of all that God has done
for us: God freed us from Egypt, redeemed us from
bondage, saved us from hunger, sustained us in plenty,
and rescued us from sword and disease. God's mercies
have never left us; so may they never leave us!

אִלּוּ פִינוּ מָלֵא שִׁירָה כַּיָּם, וּלְשׁוֹנֵנוּ רִנָּה כַּהֲמוֹן
גַּלָּיו, וְשִׂפְתוֹתֵינוּ שֶׁבַח כְּמֶרְחֲבֵי רָקִיעַ,
וְעֵינֵינוּ מְאִירוֹת כַּשֶּׁמֶשׁ וְכַיָּרֵחַ, וְיָדֵינוּ פְרוּשׂוֹת
כְּנִשְׁרֵי שָׁמָיִם. וְרַגְלֵינוּ קַלּוֹת כָּאַיָּלוֹת, אֵין אֲנַחְנוּ
מַסְפִּיקִים, לְהוֹדוֹת לְךָ יְיָ אֱלֹהֵינוּ וֵאלֹהֵי
אֲבוֹתֵינוּ, וּלְבָרֵךְ אֶת שִׁמְךָ עַל אַחַת מֵאֶלֶף אֶלֶף
אַלְפֵי אֲלָפִים וְרִבֵּי רְבָבוֹת פְּעָמִים, הַטּוֹבוֹת
שֶׁעָשִׂיתָ עִם אֲבוֹתֵינוּ וְעִמָּנוּ. מִמִּצְרַיִם גְּאַלְתָּנוּ
יְיָ אֱלֹהֵינוּ, וּמִבֵּית עֲבָדִים פְּדִיתָנוּ, בְּרָעָב זַנְתָּנוּ,
וּבְשָׂבָע כִּלְכַּלְתָּנוּ, מֵחֶרֶב הִצַּלְתָּנוּ, וּמִדֶּבֶר
מִלַּטְתָּנוּ, וּמֵחֳלָיִם רָעִים וְנֶאֱמָנִים דִּלִּיתָנוּ:
עַד הֵנָּה עֲזָרוּנוּ רַחֲמֶיךָ, וְלֹא עֲזָבוּנוּ חֲסָדֶיךָ
וְאַל תִּטְּשֵׁנוּ יְיָ אֱלֹהֵינוּ לָנֶצַח.

OUR LIMBS THAT YOU HAVE FORMED, our spirit
that You have given us, our tongues that You have
placed in our mouths – all these shall praise You in
every way possible! Every mouth shall thank You,
every tongue shall pledge loyalty, every knee shall bend
to You, and every head shall bow to You! Every heart
shall revere You, and every fibre of every being shall
sing Your praises forever more, just as King David said,
"All my bones shall say, 'Who is like You, God, saving
the weak from the powerful and the needy from the
oppressor?'" (Psalms 35:10)

עַל כֵּן אֵבָרִים שֶׁפִּלַּגְתָּ בָּנוּ, וְרוּחַ וּנְשָׁמָה
שֶׁנָּפַחְתָּ בְּאַפֵּינוּ, וְלָשׁוֹן אֲשֶׁר שַׂמְתָּ בְּפִינוּ.
הֵן הֵם יוֹדוּ וִיבָרְכוּ וִישַׁבְּחוּ וִיפָאֲרוּ וִירוֹמְמוּ
וְיַעֲרִיצוּ וְיַקְדִּישׁוּ וְיַמְלִיכוּ אֶת שִׁמְךָ מַלְכֵּנוּ. כִּי
כָל פֶּה לְךָ יוֹדֶה, וְכָל לָשׁוֹן לְךָ תִשָּׁבַע. וְכָל
בֶּרֶךְ לְךָ תִכְרַע. וְכָל קוֹמָה לְפָנֶיךָ תִשְׁתַּחֲוֶה,
וְכָל לְבָבוֹת יִירָאוּךָ, וְכָל קֶרֶב וּכְלָיוֹת יְזַמְּרוּ
לִשְׁמֶךָ. כַּדָּבָר שֶׁכָּתוּב. כָּל עַצְמוֹתַי תֹּאמַרְנָה
יְיָ מִי כָמוֹךָ. מַצִּיל עָנִי מֵחָזָק מִמֶּנּוּ, וְעָנִי וְאֶבְיוֹן

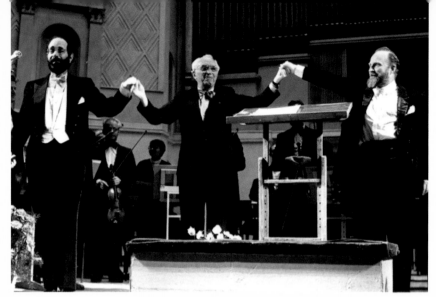

IN THE FORMER SOVIET UNION *and in Eastern Europe, JDC's support for Jewish renewal activities has encouraged Jews of all ages to rediscover and reclaim their Jewish heritage — and resurgent communities to take their place once more as proud members of the world Jewish family. As Heinz Eppler so presciently stated in his farewell remarks as JDC's president in December 1988:*

"Our ultimate goal was to reach each and every Jew (in the Soviet bloc)....
It all seems so easy today in hindsight ... but over the years each step forward was a major breakthrough, and every mile we traveled was long and hard. The rewards, of course, make the effort worthwhile...."

Who is like You, who is equal to You, and who can be compared to You? You are mighty and great, God, creator of heaven and earth! We shall praise Your name forever, just as David said, "Bless God, O my soul; all that is within me, bless God's holy name!"

מִגְּזְלוֹ: מִי יִדְמֶה לָּךְ, וּמִי יִשְׁוֶה לָּךְ, וּמִי יַעֲרָךְ לָךְ: הָאֵל הַגָּדוֹל הַגִּבּוֹר וְהַנּוֹרָא, אֵל עֶלְיוֹן קֹנֵה שָׁמַיִם וָאָרֶץ: נְהַלֶּלְךָ וּנְשַׁבֵּחֲךָ וּנְפָאֶרְךָ וּנְבָרֵךְ אֶת־שֵׁם קָדְשֶׁךָ, כָּאָמוּר, לְדָוִד, בָּרְכִי נַפְשִׁי אֶת יְיָ, וְכָל קְרָבַי אֶת שֵׁם קָדְשׁוֹ:

ALMIGHTY GOD, mighty and glorious, tremendous in action, enthroned on high.

הָאֵל בְּתַעֲצֻמוֹת עֻזֶּךָ, הַגָּדוֹל בִּכְבוֹד שְׁמֶךָ, הַגִּבּוֹר לָנֶצַח וְהַנּוֹרָא בְּנוֹרְאוֹתֶיךָ, הַמֶּלֶךְ הַיּוֹשֵׁב עַל כִּסֵּא רָם וְנִשָּׂא:

LIVING THROUGHOUT ETERNITY, exalted and holy is Your name. As it is written, "Sing joyfully, God's righteous ones! Praise becomes the upright" (Psalms 33:1). You will be praised by the mouths of the upright and blessed by the words of the righteous! You will be exalted by the tongues of the pious and sanctified in the midst of the holy!

שׁוֹכֵן עַד, מָרוֹם וְקָדוֹשׁ שְׁמוֹ: וְכָתוּב, רַנְּנוּ צַדִּיקִים בַּיְיָ, לַיְשָׁרִים נָאוָה תְהִלָּה. בְּפִי יְשָׁרִים תִּתְהַלָּל. וּבְדִבְרֵי צַדִּיקִים תִּתְבָּרַךְ. וּבִלְשׁוֹן חֲסִידִים תִּתְרוֹמָם. וּבְקֶרֶב קְדוֹשִׁים תִּתְקַדָּשׁ:

FURTHERMORE, the assembled throngs of the house of Israel glorify You in song in every generation, for this is the duty of all creatures — to praise, extol, revere and bless Your name, even more than the words of the psalms of Your anointed servant David. May God's great and holy name be praised for ever and ever! It is fitting to praise You with song, with blessing and with thanksgiving now and forever more!

MAY YOUR NAME be praised forever, our King, the great and holy God and King in heaven and on earth. For to You, Lord our God and God of our ancestors, it is fitting to offer song and praise, hymn and psalm, strength and dominion, eternity, greatness and might, glory and renown, holiness and kingship, blessings and thanks, from now and forever. Blessed are You, Lord, God and King exalted in praises, God of thanksgivings, Master of wonders, who delights in songs of praise, King, God, Giver of life to the universe.

Lift the fourth cup of wine and recite:
(On Shabbat, add the words in parentheses.)

BLESSED ARE YOU, Lord our God,
King of the universe, who creates the fruit of the vine.

Barukh atah Adonai, Eloheinu melekh ha-olam,
borei pri hagafen.

BLESSED ARE YOU, Lord our God, King of the universe, who has created the vine and its fruit, the produce of the field and the special land given to our ancestors that they might eat of its fruit and enjoy its goodness. May God have mercy on Jerusalem, on Zion, and on the Temple mount, rebuilding Jerusalem as a holy city in our lifetime and bringing us there to rejoice in her rebuilding; there we may eat the fruit of the land and be satisfied, praising God in holiness and purity. (Strengthen us on this day of Shabbat and) Make us rejoice in this holiday of Pesach, for You are good and do good to all; we therefore thank You for the land and the fruit of the vine. Blessed is God for the land and the fruit of the vine.

וּבְמַקְהֲלוֹת רִבְבוֹת עַמְּךָ בֵּית יִשְׂרָאֵל, בְּרִנָּה יִתְפָּאֵר שִׁמְךָ מַלְכֵּנוּ, בְּכָל דּוֹר וָדוֹר, שֶׁכֵּן חוֹבַת כָּל הַיְצוּרִים, לְפָנֶיךָ יְיָ אֱלֹהֵינוּ, וֵאלֹהֵי אֲבוֹתֵינוּ, לְהוֹדוֹת לְהַלֵּל לְשַׁבֵּחַ לְפָאֵר לְרוֹמֵם לְהַדֵּר לְבָרֵךְ לְעַלֵּה וּלְקַלֵּס. עַל כָּל דִּבְרֵי שִׁירוֹת וְתִשְׁבְּחוֹת דָּוִד בֶּן יִשַׁי עַבְדְּךָ מְשִׁיחֶךָ:

יִשְׁתַּבַּח שִׁמְךָ לָעַד מַלְכֵּנוּ, הָאֵל הַמֶּלֶךְ הַגָּדוֹל וְהַקָּדוֹשׁ בַּשָּׁמַיִם וּבָאָרֶץ. כִּי לְךָ נָאֶה, יְיָ אֱלֹהֵינוּ וֵאלֹהֵי אֲבוֹתֵינוּ, שִׁיר וּשְׁבָחָה, הַלֵּל וְזִמְרָה, עֹז וּמֶמְשָׁלָה, נֶצַח, גְּדֻלָּה וּגְבוּרָה, תְּהִלָּה וְתִפְאֶרֶת, קְדֻשָּׁה וּמַלְכוּת. בְּרָכוֹת וְהוֹדָאוֹת מֵעַתָּה וְעַד עוֹלָם. בָּרוּךְ אַתָּה יְיָ, אֵל מֶלֶךְ גָּדוֹל בַּתִּשְׁבָּחוֹת, אֵל הַהוֹדָאוֹת, אֲדוֹן הַנִּפְלָאוֹת, הַבּוֹחֵר בְּשִׁירֵי זִמְרָה, מֶלֶךְ אֵל חֵי הָעוֹלָמִים.

בָּרוּךְ אַתָּה יְיָ, אֱלֹהֵינוּ מֶלֶךְ הָעוֹלָם. בּוֹרֵא פְּרִי הַגָּפֶן:

בָּרוּךְ אַתָּה יְיָ, אֱלֹהֵינוּ מֶלֶךְ הָעוֹלָם. עַל הַגֶּפֶן וְעַל פְּרִי הַגֶּפֶן, וְעַל תְּנוּבַת הַשָּׂדֶה, וְעַל אֶרֶץ חֶמְדָּה טוֹבָה וּרְחָבָה, שֶׁרָצִיתָ וְהִנְחַלְתָּ לַאֲבוֹתֵינוּ, לֶאֱכוֹל מִפִּרְיָהּ וְלִשְׂבּוֹעַ מִטּוּבָהּ. רַחֶם נָא יְיָ אֱלֹהֵינוּ עַל יִשְׂרָאֵל עַמֶּךָ, וְעַל יְרוּשָׁלַיִם עִירֶךָ, וְעַל צִיּוֹן מִשְׁכַּן כְּבוֹדֶךָ, וְעַל מִזְבְּחֶךָ וְעַל הֵיכָלֶךָ. וּבְנֵה יְרוּשָׁלַיִם עִיר הַקֹּדֶשׁ בִּמְהֵרָה בְיָמֵינוּ, וְהַעֲלֵנוּ לְתוֹכָהּ, וְשַׂמְּחֵנוּ בְּבִנְיָנָהּ וְנֹאכַל מִפִּרְיָהּ וְנִשְׂבַּע מִטּוּבָהּ, וּנְבָרֶכְךָ עָלֶיהָ בִּקְדֻשָּׁה וּבְטָהֳרָה (בְּשַׁבָּת וּרְצֵה וְהַחֲלִיצֵנוּ בְּיוֹם הַשַּׁבָּת הַזֶּה) וְשַׂמְּחֵנוּ בְּיוֹם חַג הַמַּצּוֹת הַזֶּה, כִּי אַתָּה יְיָ טוֹב וּמֵטִיב לַכֹּל, וְנוֹדֶה לְּךָ עַל הָאָרֶץ וְעַל פְּרִי הַגָּפֶן. בָּרוּךְ אַתָּה יְיָ, עַל הָאָרֶץ וְעַל פְּרִי הַגָּפֶן:

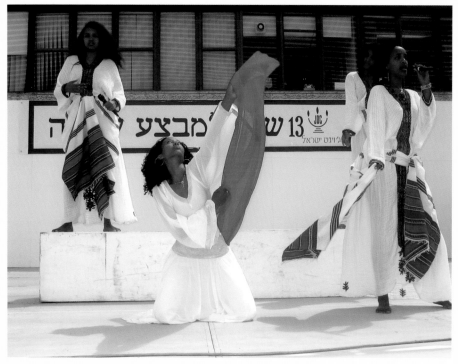

JDC ASSISTED *in the negotiation, planning, and execution of Operation Solomon, which airlifted some 14,000 Ethiopian Jews from Addis Ababa to Israel on May 24-25, 1991, just as the city was about to come under attack from rebel forces poised to take over the collapsing Marxist government. That miraculous rescue came on the heels of the year-long health and welfare program that JDC had been operating in Addis for the swelling number of Jews who had gathered there, determined to fulfill their dream of making aliyah.*

ABOVE:
Ethiopian dancers, all *olim*, celebrate the 13th anniversary of Operation Solomon in Jerusalem.
Israel, 2004. Photo: Ofir Ben Natan

IN THE YEARS *following Operation Solomon, JDC helped facilitate the emigration of some 6,000 additional Jews from Ethiopia's isolated Quara region, providing aid to those in transit in Teda on their way to Addis and then Israel. Country director Manlio Dell'Ariccia recalled meeting with the community's spiritual leader a few weeks before Passover in 1992 to discuss arrangements for the upcoming holiday:*

"We made everything according to their tradition … but at the end of the meeting I saw an expression of worry in his eyes. I asked him what was wrong and he replied (with his usual simplicity and modesty) that he was wondering whether everything had been done in the 'right way'—this, in view of the fact that the following year 'his people' would celebrate Pesach in Israel!"

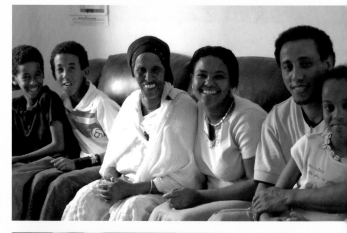

TOP RIGHT:
Members of this flourishing Ethiopian-Israeli family in Beersheva have benefited from JDC's help at various stages of their lives.
Israel, 2007. Photo: Peggy Myers

BOTTOM RIGHT:
Since 1998, PACT (Parents and Children Together) partnership programs have been narrowing the educational and social gaps between Ethiopian-Israeli children and their veteran Israeli peers.
Israel, 2008. Photo: Debbi Cooper

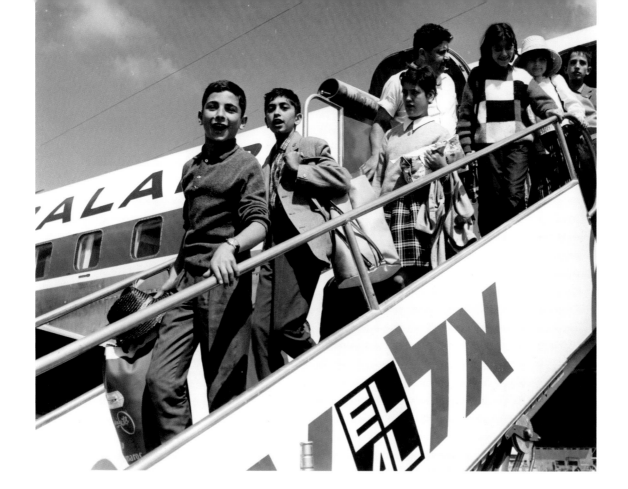

NIRTZAH

נִרְצָה

OUR PASSOVER SEDER is closed and completed; its ordered tradition in honor repeated. As our merit was great when the rite was begun, be it no less now it's ended and done. May God who dwells on high, as of old, raise the heads of Israel in numbers untold! Soon may we gather, a glorious throng; in Zion redeemed, there to burst into song!

חֲסַל סִדּוּר פֶּסַח כְּהִלְכָתוֹ, כְּכָל מִשְׁפָּטוֹ וְחֻקָּתוֹ. כַּאֲשֶׁר זָכִינוּ לְסַדֵּר אוֹתוֹ, כֵּן נִזְכֶּה לַעֲשׂוֹתוֹ. זָךְ שׁוֹכֵן מְעוֹנָה, קוֹמֵם קְהַל עֲדַת מִי מָנָה. בְּקָרוֹב נַהֵל נִטְעֵי כַנָּה, פְּדוּיִים לְצִיּוֹן בְּרִנָּה.

Next Year in Jerusalem!

לְשָׁנָה הַבָּאָה בִּירוּשָׁלָיִם:

L'shana ha'ba'a b'Yerushalaim!

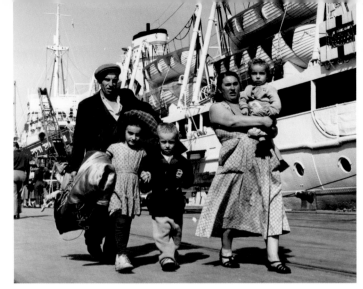

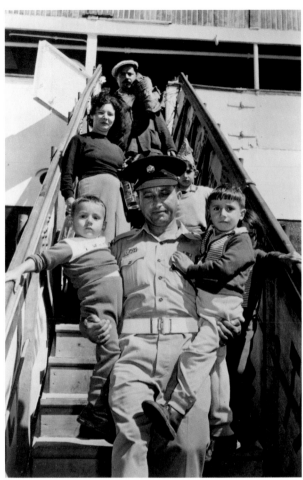

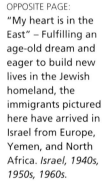

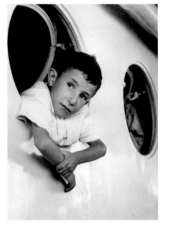

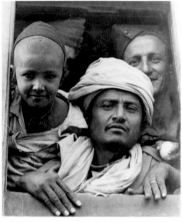

ABOVE AND
OPPOSITE PAGE:
"My heart is in the
East" – Fulfilling an
age-old dream and
eager to build new
lives in the Jewish
homeland, the
immigrants pictured
here have arrived in
Israel from Europe,
Yemen, and North
Africa. *Israel, 1940s,
1950s, 1960s.*
Photos: (this page top right
and opposite page) courtesy of
UJA Archives.

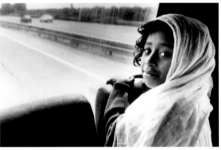

ABOVE AND RIGHT:
Ethiopian Jews come home to Israel in the
awe-inspiring Operation Solomon. *Israel, 1991.*
Photos: Richard Lobell.

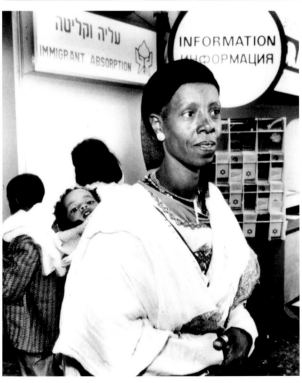

*"When I saw the film of the Ethiopian immigrants heading for
the plane," said then Israeli Defense Minister Moshe Arens,
"I thought of the exodus from Egypt."*

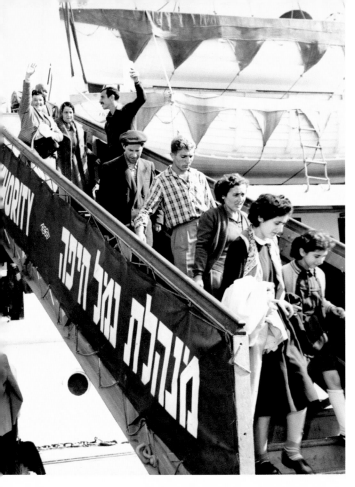

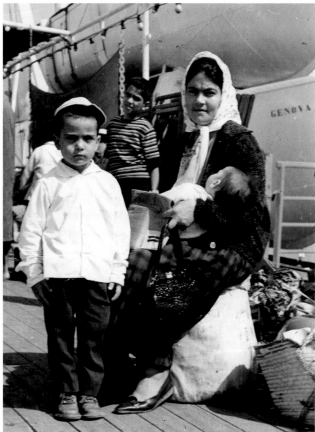

NO MATTER WHERE WE ARE; no matter where we plan to be next year; we end the formal part of the seder with this ambition: "Next year in Jerusalem." We say these words even if we are in Israel, even in Jerusalem.

The longing for Zion and Jerusalem are integral to the Jewish consciousness. Many dismiss Zionism as a modern political movement, with the Jews as one of a number of 19th century groups struggling for a national home. But as the Exodus story that we recounted tonight demonstrates, the longing for Israel goes to the very foundation of our identity as a people.

The Torah tells us that the generation of Israelites who left Egypt and wandered in the desert for 40 years never reached the Promised Land. Moses, too, perished in the desert. But the longing never died and the journey never ended. As the great Hasidic master, Rabbi Nachman of Breslov, who is buried in Ukraine, said, "Wherever I am walking, I am walking in Israel."

The dream of Zion has nurtured a people. In its relief efforts, the JDC has helped bring thousands and thousands of Jews out of danger. Many came to Israel. We see them in the accompanying photographs, arriving by ship and by plane. If we could hear them talking, we might hear words like those of the Soviet refusenik Ida Nudel, who said upon her arrival at Ben Gurion Airport:

"A few hours ago I was almost a slave in Moscow. Now I'm a free woman in my own country. It is the most important moment in my life. I am at home at the soul of the Jewish people. I am a free person among my own people."

Of course, not all Soviet Jews followed Nudel's lead. Many chose to go to America and other western countries. Many chose to stay put in their homeland. The same can be said for the Jews of Europe and North Africa. Some came, some stayed and some went elsewhere.

There was no one solution for all. Throughout its history, JDC recognized that different communities and different people had different yearnings. JDC kept its promise to provide rescue, relief and renewal. It reminded people that redemption is not just something we read about in the past but something that can – and does – happen in the here and now.

On this night of Passover, while gathered around the seder table with friends and family, we retell and, in some ways, relive the story of the Exodus. It is an invaluable annual lesson in giving and sharing.

IN THE YEARS *following World War II, JDC was engaged in an unrelenting effort to help the Holocaust survivors in its care begin their lives anew in Israel and in other parts of the world. Charles Jordan, who would later became Executive Vice Chairman of JDC, saw the potential haven that Australia represented when he visited there in mid-1947, hoping to secure government permission to re-settle 2,000 Jewish refugees then in his charge in Shanghai:*

"They call this God's country," he wrote, "and right they are…. As I watch these happy people here … I see before me the faces for whom we care, and knowing as I do of the urgent need of this country for an increase in population, I wonder how many of those who need it most will find their way to this haven."

Working in partnership with the Australian Jewish community and its existing aid organizations, JDC subsequently provided the means to bring 25,000 Jews to Australia and help them establish themselves in their new society.

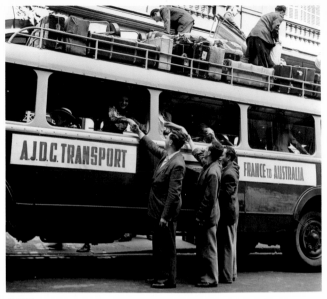

ABOVE:
Bound for new lives in Australia, refugees from Poland and the DP camps get a fond send-off from JDC staff. *France, circa 1947.*
BELOW: In their newfound haven in Kobe, yeshiva students are free to pursue their studies. *Japan, 1941.*
OPPOSITE PAGE: Disembarking in the Port of Haifa, displaced Jewish families from Europe and North Africa have found a new home. *Israel, 1950s.*

"I HAVE NOT TOLD YOU of the fervency with which the Rabbis and Yeshiva students, who are now on their way from Lithuania across the wastes of Siberia to the Pacific Ocean, will celebrate Passover and draw a parallel between their own deliverance, effected by the JDC, and the deliverance of the Jews from Egypt."

— From a 1941 report by Morris C. Troper, director of JDC's European operations, describing the wartime struggle to supply Passover foods to Jews living under Nazi rule and those who made it to countries of refuge.

On the first night recite:

AND THUS IT CAME TO PASS
AT MIDNIGHT

Long ago you performed most wonders at night.
On the first of the watches on this very same night.
You brought victory to Abraham
 who split his army at night.
It came to pass at midnight!

You judged the King of Gerar in a dream at night.
You terrified Laban in the dark of the night.
And Israel beat back the angel at night.
It came to pass at midnight!

The firstborn of Egypt you crushed at midnight.
Their power was gone when they rose in the night.
Sisera's army was driven down in the night.
It came to pass at midnight!

The blasphemer attacked and you destroyed him at night.
Bel and his pedestal were brought down
 in the heart of the night.
To Daniel the secret was shown in the night.
It came to pass at midnight!

He who drank from the cup was killed in the night.
And Daniel unraveled the dream terrors of night.
Haman wrote down his awful decrees in the night.
It came to pass at midnight!

You did him in through a king's sleepless walking at night.
You tread the winepress for all asking
 'Watchman, what of the night.'
Like the watchman you cry morning
 has come with the night.
It came to pass at midnight!

Soon the day comes which is no day and no night.
O Most High please say that yours is day and yours night.
Place watchmen in your city all day and all night.
Make the light of day shine in the darkness of night.
It came to pass at midnight!

 וּבְכֵן וַיְהִי בַּחֲצִי הַלַּיְלָה

אָז רוֹב נִסִּים הִפְלֵאתָ בַּלַּיְלָה.
בְּרֹאשׁ אַשְׁמוּרוֹת זֶה הַלַּיְלָה.
גֵּר צֶדֶק נִצַּחְתּוֹ כְּנֶחֱלַק לוֹ לַיְלָה.
וַיְהִי בַּחֲצִי הַלַּיְלָה.

דַּנְתָּ מֶלֶךְ גְּרָר בַּחֲלוֹם הַלַּיְלָה.
הִפְחַדְתָּ אֲרַמִּי בְּאֶמֶשׁ לַיְלָה.
וַיָּשַׂר יִשְׂרָאֵל לְמַלְאָךְ וַיּוּכַל לוֹ לַיְלָה.
וַיְהִי בַּחֲצִי הַלַּיְלָה.

זֶרַע בְּכוֹרֵי פַתְרוֹס מָחַצְתָּ בַּחֲצִי הַלַּיְלָה.
חֵילָם לֹא מָצְאוּ בְּקוּמָם בַּלַּיְלָה.
טִיסַת נְגִיד חֲרֹשֶׁת סִלִּיתָ בְּכוֹכְבֵי לַיְלָה.
וַיְהִי בַּחֲצִי הַלַּיְלָה.

יָעַץ מְחָרֵף לְנוֹפֵף אִוּוּי הוֹבַשְׁתָּ פְּגָרָיו בַּלַּיְלָה.
כָּרַע בֵּל וּמַצָּבוֹ בְּאִישׁוֹן לַיְלָה.
לְאִישׁ חֲמוּדוֹת נִגְלָה רָז חֲזוֹת לַיְלָה.
וַיְהִי בַּחֲצִי הַלַּיְלָה.

מִשְׁתַּכֵּר בִּכְלֵי קֹדֶשׁ נֶהֱרַג בּוֹ בַּלַּיְלָה.
נוֹשַׁע מִבּוֹר אֲרָיוֹת פּוֹתֵר בִּעֲתוּתֵי לַיְלָה.
שִׂנְאָה נָטַר אֲגָגִי וְכָתַב סְפָרִים בַּלַּיְלָה.
וַיְהִי בַּחֲצִי הַלַּיְלָה.

עוֹרַרְתָּ נִצְחֲךָ עָלָיו בְּנֶדֶד שְׁנַת לַיְלָה.
פּוּרָה תִדְרוֹךְ לְשׁוֹמֵר מַה מִלַּיְלָה.
צָרַח כַּשּׁוֹמֵר וְשָׂח אָתָא בֹקֶר וְגַם לַיְלָה.
וַיְהִי בַּחֲצִי הַלַּיְלָה.

קָרֵב יוֹם אֲשֶׁר הוּא לֹא יוֹם וְלֹא לַיְלָה.
רָם הוֹדַע כִּי לְךָ הַיּוֹם אַף לְךָ הַלַּיְלָה.
שׁוֹמְרִים הַפְקֵד לְעִירְךָ כָּל הַיּוֹם וְכָל הַלַּיְלָה.
תָּאִיר כְּאוֹר יוֹם חֶשְׁכַּת לַיְלָה.
וַיְהִי בַּחֲצִי הַלַּיְלָה.

On the second night recite:

AND THUS YOU WILL SAY
THIS IS THE PASSOVER OFFERING

וּבְכֵן וַאֲמַרְתֶּם זֶבַח פֶּסַח

What wonderful power you displayed on Passover.
At the head of all festivals you placed the Passover.
You showed all to Abraham, the one from the East,
 on the night of Passover.
And you will say this is the Passover offering.

אֹמֶץ גְּבוּרוֹתֶיךָ הִפְלֵאתָ בַּפֶּסַח.
בְּרֹאשׁ כָּל מוֹעֲדוֹת נִשֵּׂאתָ פֶּסַח.
גִּלִּיתָ לְאֶזְרָחִי חֲצוֹת לֵיל פֶּסַח.
וַאֲמַרְתֶּם זֶבַח פֶּסַח.

You knocked on his door in the heat of the day on Passover.
He fed the angels with unleavened bread on Passover.
He ran to the cattle as though to offer one up for Passover.
And you will say this is the Passover offering.

דְּלָתָיו דָּפַקְתָּ כְּחֹם הַיּוֹם בַּפֶּסַח.
הִסְעִיד נוֹצְצִים עֻגוֹת מַצּוֹת בַּפֶּסַח.
וְאֶל הַבָּקָר רָץ זֵכֶר לְשׁוֹר עֵרֶךְ פֶּסַח.
וַאֲמַרְתֶּם זֶבַח פֶּסַח.

Sodom enraged God and shriveled in flame on Passover.
Lot managed to flee and bake unleavened bread on Passover.
You passed the land of Moph and Noph,
 swept it clean on Passover.
And you will say this is the Passover offering.

זוֹעֲמוּ סְדוֹמִים וְלוֹהֲטוּ בָּאֵשׁ בַּפֶּסַח.
חֻלַּץ לוֹט מֵהֶם וּמַצּוֹת אָפָה בְּקֵץ פֶּסַח.
טִאטֵאתָ אַדְמַת מֹף וְנֹף בְּעָבְרְךָ בַּפֶּסַח.
וַאֲמַרְתֶּם זֶבַח פֶּסַח.

Lord, you crushed Egypt's firstborn
 on the night of watching, on Passover.
And spared, Mighty One, Israel's firstborn,
 marked by sacrifice-blood on Passover.
You kept the destroyer away from my door on Passover.
And you will say this is the Passover offering.

יָהּ רֹאשׁ כָּל אוֹן מָחַצְתָּ בְּלֵיל שִׁמּוּר פֶּסַח.
כַּבִּיר, עַל בֵּן בְּכוֹר פָּסַחְתָּ בְּדַם פֶּסַח.
לְבִלְתִּי תֵּת מַשְׁחִית לָבֹא בִּפְתָחַי בַּפֶּסַח.
וַאֲמַרְתֶּם זֶבַח פֶּסַח.

The closed city of Jericho was forced to give in at Passover.
Midian was destroyed by a cake of barley,
 by the barley offered on Passover.
The corpulent ones of Pul and Lud
 were burned in great fire on Passover.
And you will say this is the Passover offering.

מְסֻגֶּרֶת סֻגָּרָה בְּעִתּוֹתֵי פֶּסַח.
נִשְׁמְדָה מִדְיָן בִּצְלִיל שְׂעוֹרֵי עֹמֶר פֶּסַח.
שׂוֹרְפוּ מִשְׁמַנֵּי פּוּל וְלוּד בִּיקַד יְקוֹד פֶּסַח.
וַאֲמַרְתֶּם זֶבַח פֶּסַח.

The King of Assyria tarried in Nob till the time of Passover.
Babylon's writ of destruction your hand
 inscribed on Passover.
The watch was set and the table was set on Passover.
And you will say this is the Passover offering.

עוֹד הַיּוֹם בְּנֹב לַעֲמוֹד עַד גָּעָה עוֹנַת פֶּסַח.
פַּס יָד כָּתְבָה לְקַעֲקֵעַ צוּל בַּפֶּסַח.
צָפֹה הַצָּפִית עָרוֹךְ הַשֻּׁלְחָן בַּפֶּסַח.
וַאֲמַרְתֶּם זֶבַח פֶּסַח.

Esther gathered her people for a three-day fast on Passover.
You hung the evil one's head from a fifty-foot pole on Passover.
Two times this destruction you will
 instantly bring to Utz on Passover.
Let your hand be strong, your right hand rise up
 as on the night you hallowed Passover.
And you will say this is the Passover offering.

קָהָל כִּנְּסָה הֲדַסָּה צוֹם לְשַׁלֵּשׁ בַּפֶּסַח.
רֹאשׁ מִבֵּית רָשָׁע מָחַצְתָּ בְּעֵץ חֲמִשִּׁים בַּפֶּסַח.
שְׁתֵּי אֵלֶּה רֶגַע תָּבִיא לְעוּצִית בַּפֶּסַח.
תָּעֹז יָדְךָ וְתָרוּם יְמִינֶךָ כְּלֵיל הִתְקַדֵּשׁ חַג פֶּסַח.
וַאֲמַרְתֶּם זֶבַח פֶּסַח.

KI LO NA'EH

כִּי לוֹ נָאֶה

August in royalty,
Brilliant in law,
Can anyone be compared to God,
To whom all praise is due?
"Praise is due to You!"

אַדִּיר בִּמְלוּכָה,
בָּחוּר כַּהֲלָכָה, גְּדוּדָיו יֹאמְרוּ לוֹ:
לְךָ וּלְךָ, לְךָ כִּי לְךָ, לְךָ אַף לְךָ,
לְךָ יְיָ הַמַּמְלָכָה.
כִּי לוֹ נָאֶה, כִּי לוֹ יָאֶה.

Decked in royalty,
Excellent in law,
Far and wide God's name rings true.
"Praise is due to You!"

דָּגוּל בִּמְלוּכָה,
הָדוּר כַּהֲלָכָה, וְתִיקָיו יֹאמְרוּ לוֹ:
לְךָ וּלְךָ, לְךָ כִּי לְךָ, לְךָ אַף לְךָ,
לְךָ יְיָ הַמַּמְלָכָה.
כִּי לוֹ נָאֶה, כִּי לוֹ יָאֶה.

Glorious in royalty,
Hallowed in law,
In every sphere God's praise is due.
"Praise is due to You!"

זַכַּאי בִּמְלוּכָה,
חָסִין כַּהֲלָכָה, טַפְסְרָיו יֹאמְרוּ לוֹ:
לְךָ וּלְךָ, לְךָ כִּי לְךָ, לְךָ אַף לְךָ,
לְךָ יְיָ הַמַּמְלָכָה.
כִּי לוֹ נָאֶה, כִּי לוֹ יָאֶה.

Just in royalty,
Knowledgeable in law,
Let every creature say it, too:
"Praise is due to You!"

יָחִיד בִּמְלוּכָה,
כַּבִּיר כַּהֲלָכָה, לִמּוּדָיו יֹאמְרוּ לוֹ:
לְךָ וּלְךָ, לְךָ כִּי לְךָ,
לְךָ אַף לְךָ, לְךָ יְיָ הַמַּמְלָכָה.
כִּי לוֹ נָאֶה, כִּי לוֹ יָאֶה.

Marvelous in royalty,
Nonpareil in law,
One and all declare it's true:
"Praise is due to You!"

מוֹשֵׁל בִּמְלוּכָה,
נוֹרָא כַּהֲלָכָה, סְבִיבָיו יֹאמְרוּ לוֹ:
לְךָ וּלְךָ, לְךָ כִּי לְךָ, לְךָ אַף לְךָ,
לְךָ יְיָ הַמַּמְלָכָה.
כִּי לוֹ נָאֶה, כִּי לוֹ יָאֶה.

FORWARDING A RECORDING *of the Passover program broadcast by Radio Warsaw in April 1982, JDC country director Akiva Kohane called it historic, saying, "I don't know if the Jews of Poland — and not only of Poland — have ever heard over Polish state radio 'Next year in Jerusalem'."*

The program initiated a series of holiday broadcasts whose listening audience included Jews living in Czechoslovakia, Hungary, and the western portions of the Soviet Union, where access to Jewish culture and religion was restricted by the region's Communist regimes. Kohane thus deemed it "a great achievement that today a radio station in the Communist bloc is giving a program on Jewish holidays, using Hebrew prayers and songs."

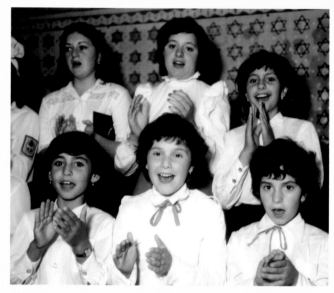

ABOVE:
Young voices lifted in holiday song are the highlight of a Jewish community celebration. *Romania, circa 1990.*

Peerless in royalty,
Quintessence of law,
Revered is God, whose praise is due.
"Praise is due to You!"

עָנָו בִּמְלוּכָה,
פּוֹדֶה כַּהֲלָכָה, צַדִּיקָיו יֹאמְרוּ לוֹ:
לְךָ וּלְךָ, לְךָ כִּי לְךָ, לְךָ אַף לְךָ,
לְךָ יְיָ הַמַּמְלָכָה.
כִּי לוֹ נָאֶה, כִּי לוֹ יָאֶה.

Supreme in royalty,
Talmudic in law,
Ultimately all praises must accrue.
"Praise is due to You!"

קָדוֹשׁ בִּמְלוּכָה,
רַחוּם כַּהֲלָכָה, שִׁנְאַנָּיו יֹאמְרוּ לוֹ:
לְךָ וּלְךָ, לְךָ כִּי לְךָ, לְךָ אַף לְךָ,
לְךָ יְיָ הַמַּמְלָכָה.
כִּי לוֹ נָאֶה, כִּי לוֹ יָאֶה.

Venerable in royalty,
Wonderful in law,
XYZ – our list is through!
"Praise is due to You!"

תַּקִּיף בִּמְלוּכָה,
תּוֹמֵךְ כַּהֲלָכָה, תְּמִימָיו יֹאמְרוּ לוֹ:
לְךָ וּלְךָ, לְךָ כִּי לְךָ, לְךָ אַף לְךָ,
לְךָ יְיָ הַמַּמְלָכָה.
כִּי לוֹ נָאֶה, כִּי לוֹ יָאֶה.

ADIR HU!

<div dir="rtl">

אַדִּיר הוּא

אַדִּיר הוּא, אַדִּיר הוּא, יִבְנֶה בֵּיתוֹ בְּקָרוֹב.
בִּמְהֵרָה בִּמְהֵרָה, בְּיָמֵינוּ בְּקָרוֹב.
אֵל בְּנֵה, אֵל בְּנֵה, בְּנֵה בֵּיתְךָ בְּקָרוֹב.

בָּחוּר הוּא, גָּדוֹל הוּא, דָּגוּל הוּא,
יִבְנֶה בֵּיתוֹ בְּקָרוֹב, בִּמְהֵרָה בִּמְהֵרָה,
בְּיָמֵינוּ בְּקָרוֹב.
אֵל בְּנֵה, אֵל בְּנֵה, בְּנֵה בֵּיתְךָ בְּקָרוֹב.

הָדוּר הוּא, וָתִיק הוּא,
זַכַּאי הוּא, חָסִיד הוּא,
יִבְנֶה בֵּיתוֹ בְּקָרוֹב, בִּמְהֵרָה בִּמְהֵרָה, בְּיָמֵינוּ
בְּקָרוֹב. אֵל בְּנֵה, אֵל בְּנֵה, בְּנֵה בֵּיתְךָ בְּקָרוֹב.

טָהוֹר הוּא, יָחִיד הוּא, כַּבִּיר הוּא,
יִבְנֶה בֵּיתוֹ בְּקָרוֹב, בִּמְהֵרָה בִּמְהֵרָה, בְּיָמֵינוּ
בְּקָרוֹב. אֵל בְּנֵה, אֵל בְּנֵה, בְּנֵה בֵּיתְךָ בְּקָרוֹב.

לָמוּד הוּא, מֶלֶךְ הוּא, נוֹרָא הוּא,
יִבְנֶה בֵּיתוֹ בְּקָרוֹב, בִּמְהֵרָה בִּמְהֵרָה, בְּיָמֵינוּ
בְּקָרוֹב. אֵל בְּנֵה, אֵל בְּנֵה, בְּנֵה בֵּיתְךָ בְּקָרוֹב.

סַגִּיב הוּא, עִזּוּז הוּא,
פּוֹדֶה הוּא, צַדִּיק הוּא,
יִבְנֶה בֵּיתוֹ בְּקָרוֹב, בִּמְהֵרָה בִּמְהֵרָה, בְּיָמֵינוּ
בְּקָרוֹב. אֵל בְּנֵה, אֵל בְּנֵה, בְּנֵה בֵּיתְךָ בְּקָרוֹב.

קָדוֹשׁ הוּא, רַחוּם הוּא,
שַׁדַּי הוּא, תַּקִּיף הוּא,
יִבְנֶה בֵּיתוֹ בְּקָרוֹב, בִּמְהֵרָה בִּמְהֵרָה, בְּיָמֵינוּ
בְּקָרוֹב. אֵל בְּנֵה, אֵל בְּנֵה, בְּנֵה בֵּיתְךָ בְּקָרוֹב.

</div>

Awesome One,
Rebuild Your house in our lifetime!
Rebuild it God, speedily.

Blessed One, Celestial One, Divine One,
Rebuild Your house in our lifetime!
Rebuild it God, speedily.

Ethereal One, Fabulous One, Glorious One,
Rebuild Your house in our lifetime!
Rebuild it God, speedily.

Heavenly One, Invisible One, Just One,
Rebuild Your house in our lifetime!
Rebuild it God, speedily.

Kindly One, Lauded One, Mighty One,
Rebuild Your house in our lifetime!
Rebuild it God, speedily.

Noble One, Omnipotent One, Peerless One,
Rebuild Your house in our lifetime!
Rebuild it God, speedily.

Regal One, Sublime One, Transcendant One,
Rebuild Your house in our lifetime!
Rebuild it God, speedily.

Universal One, Venerated One, Watchful One,
Rebuild Your house in our lifetime!
Rebuild it God, speedily.

ADIR HU

A-dir hu, a-dir hu
Yiv-ne vay-to b'ka-rov
Bim-hay-ra, bim-hay-ra
B'ya-may-nu b'ka-rov
Ayl b'nay, ayl b'nay
B'nay vayt-cha b'ka-rov.

Ba-chur hu, ga-dol hu, da-gul hu
Yiv-neh vay-to b'ka-rov
Bim-hay-ra, bim-hay-ra
B'ya-may-nu b'ka-rov
Ayl b'nay, ayl b'nay
B'nay vayt-cha b'ka rov.

Ha-dur hu, va-teek hu, za-kay hu, chasid-hu
Yiv-neh vay-to b'ka-rov
Bim-hay-ra, bim-hay-ra
B'ya-may-nu b'ka-ro
Ayl b'nay, ayl b'nay
B'nay vayt-cha b'ka-rov.

Ta-hor hu, ya-cheed hu, ka-beer hu
Yiv-neh vay-to b'ka-rov
Bim-hay-ra, bim-hay-ra
B'ya-may-nu b'ka-rov
Ayl b'nay, ayl b'nay
B'nay vayt-cha b'ka-rov.

La-mud hu, me-lech hu, no-ra hu,
Yiv-neh vay-to b'ka-rov
Bim-hay-ra, bim-hay-ra
B'ya-may-nu b'ka-rov
Ayl b'nay, ayl b'nay
B'nay vayt-cha b'ka-rov.

Sa-geev hu, ee-zuz hu, po-deh hu,
tza-deek hu
Yiv-neh vay-to b'ka-rov
Bim-hay-ra, bim-hay-ra
B'ya-may-nu b'ka-rov
Ayl b'nay, ayl b'nay
B'nay vayt-cha b'ka-rov.

Ka-dosh hu, ra-chum hu, sha-dai hu, ta-keef hu
Yiv-neh vay-to b'ka-rov
Bim-hay-ra, bim-hay-ra
B'ya-may-nu b'ka-rov
Ayl b'nay, ayl b'nay
B'nay vayt-cha b'ka-rov.

ECHAD MI YO'DE'A?

<div dir="rtl">

אֶחָד מִי יוֹדֵעַ?

אֶחָד מִי יוֹדֵעַ?
אֶחָד אֲנִי יוֹדֵעַ: אֶחָד אֱלֹהֵינוּ
שֶׁבַּשָּׁמַיִם וּבָאָרֶץ.

שְׁנַיִם מִי יוֹדֵעַ?
שְׁנַיִם אֲנִי יוֹדֵעַ: שְׁנֵי לֻחוֹת הַבְּרִית,
אֶחָד אֱלֹהֵינוּ שֶׁבַּשָּׁמַיִם וּבָאָרֶץ.

שְׁלֹשָׁה מִי יוֹדֵעַ?
שְׁלֹשָׁה אֲנִי יוֹדֵעַ: שְׁלֹשָׁה אָבוֹת.
שְׁנֵי לֻחוֹת הַבְּרִית,
אֶחָד אֱלֹהֵינוּ שֶׁבַּשָּׁמַיִם וּבָאָרֶץ.

אַרְבַּע מִי יוֹדֵעַ?
אַרְבַּע אֲנִי יוֹדֵעַ: אַרְבַּע אִמָּהוֹת,
שְׁלֹשָׁה אָבוֹת,
שְׁנֵי לֻחוֹת הַבְּרִית,
אֶחָד אֱלֹהֵינוּ שֶׁבַּשָּׁמַיִם וּבָאָרֶץ.

חֲמִשָּׁה מִי יוֹדֵעַ?
חֲמִשָּׁה אֲנִי יוֹדֵעַ: חֲמִשָּׁה חוּמְשֵׁי תּוֹרָה,
אַרְבַּע אִמָּהוֹת,
שְׁלֹשָׁה אָבוֹת,
שְׁנֵי לֻחוֹת הַבְּרִית,
אֶחָד אֱלֹהֵינוּ שֶׁבַּשָּׁמַיִם וּבָאָרֶץ.

שִׁשָּׁה מִי יוֹדֵעַ?
שִׁשָּׁה אֲנִי יוֹדֵעַ: שִׁשָּׁה סִדְרֵי מִשְׁנָה,
חֲמִשָּׁה חוּמְשֵׁי תּוֹרָה,
אַרְבַּע אִמָּהוֹת,
שְׁלֹשָׁה אָבוֹת,
שְׁנֵי לֻחוֹת הַבְּרִית,
אֶחָד אֱלֹהֵינוּ שֶׁבַּשָּׁמַיִם וּבָאָרֶץ.

</div>

Who knows one?

I know one! One is our God
in heaven and on earth.

Who knows two?

I know two! Two are the tablets of the Ten
Commandments! One is our God in heaven and on earth.

Who knows three?

I know three! Three are the Patriarchs!
Two are the tablets of the Ten Commandments!
One is our God in heaven and on earth.

Who knows four?

I know four! Four are the Matriarchs!
Three are the Patriarchs!
Two are the tablets of the Ten Commandments!
One is our God in heaven and on earth.

Who knows five?

I know five! Five are the Books of the Torah!
Four are the Matriarchs!
Three are the Patriarchs!
Two are the tablets of the Ten Commandments!
One is our God in heaven and on earth.

Who knows six?

I know six! Six are the Orders of the Mishnah!
Five are the Books of the Torah!
Four are the Matriarchs!
Three are the Patriarchs!
Two are the tablets of the Ten Commandments!
One is our God in heaven and on earth.

Who knows seven?

I know seven! Seven are the days of the week!

Six are the Orders of the Mishnah!

Five are the Books of the Torah!

Four are the Matriarchs! Three are the Patriarchs!

Two are the tablets of the Ten Commandments!

One is our God in heaven and on earth.

Who knows eight?

I know eight! Eight are the days of the Covenant! (Brit milah, performed on the eighth day of life) Seven are the days of the week! Six are the Orders of the Mishnah!

Five are the Books of the Torah!

Four are the Matriarchs! Three are the Patriarchs!

Two are the tablets of the Ten Commandments!

One is our God in heaven and on earth.

Who knows nine?

I know nine! Nine are the months of childbirth!

Eight are the days of the Covenant! Seven are the days of the week! Six are the Orders of the Mishnah!

Five are the Books of the Torah!

Four are the Matriarchs! Three are the Patriarchs!

Two are the tablets of the Ten Commandments!

One is our God in heaven and on earth.

Who knows ten?

I know ten! Ten are the Commandments!

Nine are the months of childbirth!

Eight are the days of the Covenant!

Seven are the days of the week!

Six are the Orders of the Mishnah!

Five are the Books of the Torah! Four are the Matriarchs!

Three are the Patriarchs!

Two are the tablets of the Ten Commandments!

One is our God in heaven and on earth.

שִׁבְעָה מִי יוֹדֵעַ?

שִׁבְעָה אֲנִי יוֹדֵעַ: שִׁבְעָה יְמֵי שַׁבַּתָּא,
שִׁשָּׁה סִדְרֵי מִשְׁנָה,
חֲמִשָּׁה חוּמְשֵׁי תוֹרָה,
אַרְבַּע אִמָּהוֹת, שְׁלֹשָׁה אָבוֹת,
שְׁנֵי לֻחוֹת הַבְּרִית,
אֶחָד אֱלֹהֵינוּ שֶׁבַּשָּׁמַיִם וּבָאָרֶץ.

שְׁמוֹנָה מִי יוֹדֵעַ?

שְׁמוֹנָה אֲנִי יוֹדֵעַ: שְׁמוֹנָה יְמֵי מִילָה,
שִׁבְעָה יְמֵי שַׁבַּתָּא,
שִׁשָּׁה סִדְרֵי מִשְׁנָה,
חֲמִשָּׁה חוּמְשֵׁי תוֹרָה,
אַרְבַּע אִמָּהוֹת, שְׁלֹשָׁה אָבוֹת,
שְׁנֵי לֻחוֹת הַבְּרִית,
אֶחָד אֱלֹהֵינוּ שֶׁבַּשָּׁמַיִם וּבָאָרֶץ.

תִּשְׁעָה מִי יוֹדֵעַ?

תִּשְׁעָה אֲנִי יוֹדֵעַ: תִּשְׁעָה יַרְחֵי לֵדָה,
שְׁמוֹנָה יְמֵי מִילָה, שִׁבְעָה יְמֵי שַׁבַּתָּא,
שִׁשָּׁה סִדְרֵי מִשְׁנָה,
חֲמִשָּׁה חוּמְשֵׁי תוֹרָה,
אַרְבַּע אִמָּהוֹת, שְׁלֹשָׁה אָבוֹת,
שְׁנֵי לֻחוֹת הַבְּרִית,
אֶחָד אֱלֹהֵינוּ שֶׁבַּשָּׁמַיִם וּבָאָרֶץ.

עֲשָׂרָה מִי יוֹדֵעַ?

עֲשָׂרָה אֲנִי יוֹדֵעַ: עֲשָׂרָה דִבְּרַיָּא,
תִּשְׁעָה יַרְחֵי לֵדָה, שְׁמוֹנָה יְמֵי מִילָה,
שִׁבְעָה יְמֵי שַׁבַּתָּא,
שִׁשָּׁה סִדְרֵי מִשְׁנָה,
חֲמִשָּׁה חוּמְשֵׁי תוֹרָה,
אַרְבַּע אִמָּהוֹת,
שְׁלֹשָׁה אָבוֹת,
שְׁנֵי לֻחוֹת הַבְּרִית,
אֶחָד אֱלֹהֵינוּ שֶׁבַּשָּׁמַיִם וּבָאָרֶץ.

Who knows eleven?

I know eleven! Eleven are the stars of Joseph's dream!
Ten are the Commandments! Nine are the months of
childbirth! Eight are the days of the Covenant!
Seven are the days of the week!
Six are the Orders of the Mishnah!
Five are the Books of the Torah!
Four are the Matriarchs!
Three are the Patriarchs!
Two are the tablets of the Ten Commandments!
One is our God in heaven and on earth.

Who knows twelve?

I know twelve! Twelve are the Tribes of Israel!
Eleven are the stars of Joseph's dream!
Ten are the Commandments!
Nine are the months of childbirth!
Eight are the days of the Covenant!
Seven are the days of the week!
Six are the Orders of the Mishnah!
Five are the Books of the Torah!
Four are the Matriarchs!
Three are the Patriarchs!
Two are the tablets of the Ten Commandments!
One is our God in heaven and on earth.

Who knows thirteen?

I know thirteen! Thirteen are the attributes of God!
Twelve are the Tribes of Israel! Eleven are the stars of
Joseph's dream! Ten are the Commandments!
Nine are the months of childbirth!
Eight are the days of the Covenant!
Seven are the days of the week! Six are the Orders of the
Mishnah! Five are the Books of the Torah!
Four are the Matriarchs! Three are the Patriarchs!
Two are the tablets of the Ten Commandments!
One is our God in heaven and on earth.

אַחַד עָשָׂר מִי יוֹדֵעַ?

אַחַד עָשָׂר אֲנִי יוֹדֵעַ: אַחַד עָשָׂר כּוֹכְבַיָּא,
עֲשָׂרָה דִבְּרַיָּא, תִּשְׁעָה יַרְחֵי לֵדָה,
שְׁמוֹנָה יְמֵי מִילָה,
שִׁבְעָה יְמֵי שַׁבַּתָּא.
שִׁשָּׁה סִדְרֵי מִשְׁנָה,
חֲמִשָּׁה חוּמְשֵׁי תוֹרָה,
אַרְבַּע אִמָּהוֹת,
שְׁלֹשָׁה אָבוֹת,
שְׁנֵי לֻחוֹת הַבְּרִית,
אֶחָד אֱלֹהֵינוּ שֶׁבַּשָּׁמַיִם וּבָאָרֶץ.

שְׁנֵים עָשָׂר מִי יוֹדֵעַ?

שְׁנֵים עָשָׂר אֲנִי יוֹדֵעַ: שְׁנֵים עָשָׂר שִׁבְטַיָּא,
אַחַד עָשָׂר כּוֹכְבַיָּא,
עֲשָׂרָה דִבְּרַיָּא,
תִּשְׁעָה יַרְחֵי לֵדָה,
שְׁמוֹנָה יְמֵי מִילָה,
שִׁבְעָה יְמֵי שַׁבַּתָּא.
שִׁשָּׁה סִדְרֵי מִשְׁנָה,
חֲמִשָּׁה חוּמְשֵׁי תוֹרָה,
אַרְבַּע אִמָּהוֹת,
שְׁלֹשָׁה אָבוֹת.
שְׁנֵי לֻחוֹת הַבְּרִית,
אֶחָד אֱלֹהֵינוּ שֶׁבַּשָּׁמַיִם וּבָאָרֶץ.

שְׁלֹשָׁה עָשָׂר מִי יוֹדֵעַ?

שְׁלֹשָׁה עָשָׂר אֲנִי יוֹדֵעַ: שְׁלֹשָׁה עָשָׂר מִדַּיָּא,
שְׁנֵים עָשָׂר שִׁבְטַיָּא, אַחַד עָשָׂר כּוֹכְבַיָּא,
עֲשָׂרָה דִבְּרַיָּא,
תִּשְׁעָה יַרְחֵי לֵדָה,
שְׁמוֹנָה יְמֵי מִילָה,
שִׁבְעָה יְמֵי שַׁבַּתָּא. שִׁשָּׁה סִדְרֵי מִשְׁנָה,
חֲמִשָּׁה חוּמְשֵׁי תוֹרָה,
אַרְבַּע אִמָּהוֹת, שְׁלֹשָׁה אָבוֹת,
שְׁנֵי לֻחוֹת הַבְּרִית,
אֶחָד אֱלֹהֵינוּ שֶׁבַּשָּׁמַיִם וּבָאָרֶץ.

ECHAD MI YO'DE'A

E-chad mi yo-day-a?
E-chad a-nee yo-day-a
E-chad e-lo-hay-nu she-ba-sha-ma-yim u-va-a-retz.

Sh'na-yim mi yo-day-a?
Sh'na-yim a-nee yo-da y-a
Sh'nay lu-chot ha-brit,
E-chad e-lo-hay-nu she-ba-sha-ma-yim u-va-a-retz.

Sh'lo-sha mi yo-day-a?
Sh'lo-sha a-nee yo-day-a
Sh'lo-sha a-vot, Sh'nay lu-chot ha-brit,
E-chad e-lo-hay-nu she-ba-sha-ma-yim u-va-a-retz.

Ar-ba mi yo-day-a?
Ar-ba a-nee yo-day-a
Ar-ba ee-ma-hot, Sh'lo-sha a-vot, Sh'nay lu-chot ha-brit,
E-chad e-lo-hay-nu she-ba-sha-ma-yim u-va-a-retz.

Cha-mee-sha mi yo-day-a?
Cha-mee-sha a-nee yo-day-a
Cha-mee-sha chum-shei to-rah, Ar-ba ee-ma-hot,
Sh'lo-sha a-vot, Sh'nay lu-chot ha-brit,
E-chad e-lo-hay-nu she-ba-sha-ma-yim u-va-a-retz.

Shi-sha mi yo-day-a?
Shi-sha a-nee yo-day-a
Shi-sha see-dray mee-shna, Cha-mee-sha chum-shei to-rah,
Ar-ba ee-ma-hot, Sh'lo-sha a-vot, Sh'nay lu-chot ha-brit,
E-chad e-lo-hay-nu she-ba-sha-ma-yim u-va-a-retz.

Shi-va mi yo-day-a?
Shi-va a-nee yo-day-a
Shi-va y'may shab-ta, Shi-sha see-dray mee-shna,
Cha-mee-sha chum-shei to-rah, Ar-ba ee-ma-hot,
Sh'lo-sha a-vot, Sh'nay lu-chot ha-brit,
E-chad e-lo-hay-nu she-ba-sha-ma-yim u-va-a-retz.

Sh'mo-na mi yo-day-a?
Sh'mo-na a-nee yo-day-a
Sh'mo-na y'may mee-la, Shi-va y'may shab-ta,
Shi-sha see-dray mee-shna, Cha-mee-sha chum-shei to-rah,
Ar-ba ee-ma-hot, Sh'lo-sha a-vot, Sh'nay lu-chot ha-brit,
E-chad e-lo-hay-nu she-ba-sha-ma-yim u-va-a-retz.

Tee-sha mi yo-day-a?
Tee-sha a-nee yo-day-a
Tee-sha yar-chay lay-da, Sh'mo-na y'may mee-la,
Shi-va y'may shab-ta,
Shi-sha see-dray mee-shna, Cha-mee-sha chum-shei to-rah,
Ar-ba ee-ma-hot, Sh'lo-sha a-vot, Sh'nay lu-chot ha-brit,
E-chad e-lo-hay-nu she-ba-sha-ma-yim u-va-a-retz.

A-sa-ra mi yo-day-a?
A-sa-ra a-nee yo-day-a
A-sa-ra dee-bra-ya, Tee-sha yar-chay lay-da,
Sh'mo-na y'may mee-la,
Shi-va y'may shab-ta, Shi-sha see-dray mee-shna,
Cha-mee-sha chum-shei to-rah, Ar-ba ee-ma-hot,
Sh'lo-sha a-vot, Sh'nay lu-chot ha-brit,
E-chad e-lo-hay-nu she-ba-sha-ma-yim u-va-a-retz.

A-chad a-sar mi yo-day-a?
A-chad a-sar a-nee yo-day-a
A-chad a-sar koch-va-ya, A-sa-ra dee-bra-ya,
Tee-sha yar-chay lay-da, Sh'mo-na y'may mee-la,
Shi-va y'may shab-ta, Shi-sha see-dray mee-shna,
Cha-mee-sha chum-shei to-rah, Ar-ba ee-ma-hot,
Sh'lo-sha a-vot, Sh'nay lu-chot ha-brit,
E-chad e-lo-hay-nu she-ba-sha-ma-yim u-va-a-retz.

Sh'naym a-sar mi yo-day-a?
Sh'naym a-sar a-nee yo-day-a
Sh'naym a-sar sheev-ta-ya, A-chad a-sar koch-va-ya,
A-sa-ra dee-bra-ya, Tee-sha yar-chay lay-da,
Sh'mo-na y'may mee-la, Shi-va y'may shab-ta,
Shi-sha see-dray mee-shna, Cha-mee-sha chum-shei to-rah,
Ar-ba ee-ma-hot, Sh'lo-sha a-vot, Sh'nay lu-chot ha-brit,
E-chad e-lo-hay-nu she-ba-sha-ma-yim u-va-a-retz.

Sh'lo-sha a-sar mi yo-day-a?
Sh'lo-sha a-sar a-nee yo-day-a
Sh'lo-sha a-sar mee-da-ya, Sh'naym a-sar sheev-ta-ya,
A-chad a-sar koch-va-ya, A-sa-ra dee-bra-ya,
Tee-sha yar-chay lay-da,
Sh'mo-na y'may mee-la, Shi-va y'may shab-ta,
Shi-sha see-dray mee-shna, Cha-mee-sha chum-shei to-rah,
Ar-ba ee-ma-hot, Sh'lo-sha a-vot, Sh'nay lu-chot ha-brit,
E-chad e-lo-hay-nu she-ba-sha-ma-yim u-va-a-retz.

CHAD GADYA!

<div dir="rtl">

חַד גַּדְיָא

חַד גַּדְיָא, חַד גַּדְיָא
דְּזַבִּין אַבָּא בִּתְרֵי זוּזֵי, חַד גַּדְיָא, חַד גַּדְיָא.
</div>

An only kid – an only kid that my father bought for two coins, an only kid, an only kid!

<div dir="rtl">
וְאָתָא שׁוּנְרָא, וְאָכְלָה לְגַדְיָא,
דְּזַבִּין אַבָּא בִּתְרֵי זוּזֵי,
חַד גַּדְיָא, חַד גַּדְיָא.
</div>

Along came the cat and ate the kid, that my father bought for two coins, an only kid, an only kid!

<div dir="rtl">
וְאָתָא כַלְבָּא, וְנָשַׁךְ לְשׁוּנְרָא,
דְּאָכְלָה לְגַדְיָא, דְּזַבִּין אַבָּא בִּתְרֵי זוּזֵי,
חַד גַּדְיָא, חַד גַּדְיָא.
</div>

Along came the dog and ate the cat, that ate the kid that my father bought for two coins, an only kid, an only kid!

<div dir="rtl">
וְאָתָא חוּטְרָא, וְהִכָּה לְכַלְבָּא,
דְּנָשַׁךְ לְשׁוּנְרָא, דְּאָכְלָה לְגַדְיָא,
דְּזַבִּין אַבָּא בִּתְרֵי זוּזֵי,
חַד גַּדְיָא, חַד גַּדְיָא.
</div>

Along came the stick and beat the dog, that ate the cat that ate the kid, that my father bought for two coins, an only kid, an only kid!

<div dir="rtl">
וְאָתָא נוּרָא, וְשָׂרַף לְחוּטְרָא,
דְּהִכָּה לְכַלְבָּא, דְּנָשַׁךְ לְשׁוּנְרָא, דְּאָכְלָה
לְגַדְיָא, דְּזַבִּין אַבָּא בִּתְרֵי זוּזֵי,
חַד גַּדְיָא, חַד גַּדְיָא.
</div>

Along came the fire and burned the stick, that beat the dog that ate the cat, that ate the kid that my father bought for two coins, an only kid, an only kid!

<div dir="rtl">
וְאָתָא מַיָּא, וְכָבָה לְנוּרָא,
דְּשָׂרַף לְחוּטְרָא, דְּהִכָּה לְכַלְבָּא,
דְּנָשַׁךְ לְשׁוּנְרָא, דְּאָכְלָה לְגַדְיָא,
דְּזַבִּין אַבָּא בִּתְרֵי זוּזֵי,
חַד גַּדְיָא, חַד גַּדְיָא.
</div>

Along came the water and quenched the fire, that burned the stick that beat the dog, that ate the cat that ate the kid, that my father bought for two coins, an only kid, an only kid!

<div dir="rtl">
וְאָתָא תוֹרָא, וְשָׁתָא לְמַיָּא,
דְּכָבָה לְנוּרָא, דְּשָׂרַף לְחוּטְרָא,
דְּהִכָּה לְכַלְבָּא, דְּנָשַׁךְ לְשׁוּנְרָא, דְּאָכְלָה
לְגַדְיָא, דְּזַבִּין אַבָּא בִּתְרֵי זוּזֵי,
חַד גַּדְיָא, חַד גַּדְיָא.
</div>

Along came the ox and drank the water, that quenched the fire that burned the stick, that beat the dog that ate the cat, that ate the kid that my father bought for two coins, an only kid, an only kid!

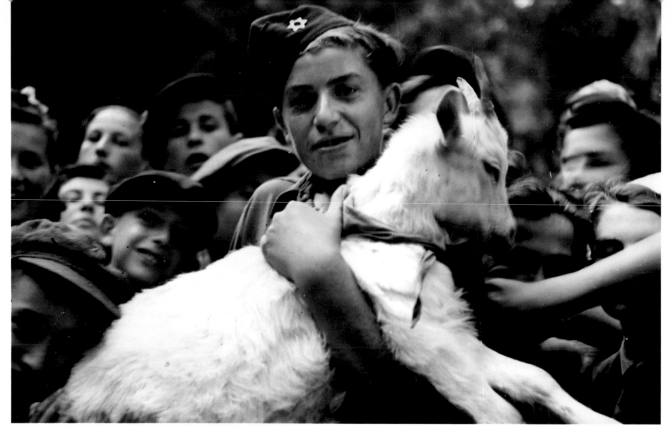

ABOVE: At Camp Biria in the Tatra Mountains, pet animals like this goat and summer play helped youngsters recover some of the joys of a childhood lost to Nazi depredations. *Czechoslovakia, late 1940s.*

Along came the butcher and slaughtered the ox, that drank the water that quenched the fire, that burned the stick that beat the dog, that ate the cat that ate the kid, that my father bought for two coins, an only kid, an only kid!

וְאָתָא הַשּׁוֹחֵט, וְשָׁחַט לְתוֹרָא,
דְּשָׁתָא לְמַיָּא, דְּכָבָה לְנוּרָא, דְּשָׂרַף לְחוּטְרָא,
דְּהִכָּה לְכַלְבָּא, דְּנָשַׁךְ לְשׁוּנְרָא,
דְּאָכְלָה לְגַדְיָא, דְּזַבִּין אַבָּא בִּתְרֵי זוּזֵי,
חַד גַּדְיָא, חַד גַּדְיָא.

Along came the angel of death and slew the butcher, that slaughtered the ox that drank the water, that quenched the fire that burned the stick, that beat the dog that ate the cat, that ate the kid that my father bought for two coins, an only kid, an only kid!

וְאָתָא מַלְאַךְ הַמָּוֶת, וְשָׁחַט לְשׁוֹחֵט,
דְּשָׁחַט לְתוֹרָא, דְּשָׁתָא לְמַיָּא, דְּכָבָה לְנוּרָא,
דְּשָׂרַף לְחוּטְרָא, דְּהִכָּה לְכַלְבָּא,
דְּנָשַׁךְ לְשׁוּנְרָא, דְּאָכְלָה לְגַדְיָא,
דְּזַבִּין אַבָּא בִּתְרֵי זוּזֵי, חַד גַּדְיָא, חַד גַּדְיָא.

Then God slew the angel of death that slew the butcher, that slaughtered the ox that drank the water, that quenched the fire that burned the stick, that beat the dog that ate the cat, that ate the kid that my father bought for two coins, an only kid, an only kid!

וְאָתָא הַקָּדוֹשׁ בָּרוּךְ הוּא,
וְשָׁחַט לְמַלְאַךְ הַמָּוֶת, דְּשָׁחַט לְתוֹרָא, דְּשָׁתָא
לְמַיָּא, דְּכָבָה לְנוּרָא, דְּשָׂרַף לְחוּטְרָא,
דְּהִכָּה לְכַלְבָּא, דְּנָשַׁךְ לְשׁוּנְרָא, דְּאָכְלָה
לְגַדְיָא, דְּזַבִּין אַבָּא בִּתְרֵי זוּזֵי,
חַד גַּדְיָא, חַד גַּדְיָא.

CHAD GADYA

Chad gad-ya, chad gad-ya

D'za-been a-ba bit-ray zu-zay
Chad gad-ya, chad gad-ya

V'a-ta shun-ra, v'ach-la l'gad-ya
D'za-been a-ba bit-ray zu-zay
Chad gad-ya, chad gad-ya

V'a-ta chut-ra v'hee-ka l'chal-ba, d'na-shach
L'shun-ra, d'ach-la l'gad-ya.
D'za-been a-ba bit-ray zu-zay
Chad gad-ya, chad gad-ya

V'a-ta nu-ra, v'sa-raf l'chut-ra, d'hee-ka l'chal-ba,
d'na-shach l'shun-ra, d'ach-la l'gad-ya
D'za-been a-ba bit-ray zu-zay
Chad gad-ya, chad gad-ya

V'a-ta ma-ya, v'cha-va l'nu-ra,
d'sa-raf l'chut-ra d'hee-ka l'chal-ba,
d'na-shach l'shun-ra, d'ach-la l'gad-ya
D'za-been a-ba bit-ray zu-zay
Chad gad-ya, chad gad-ya

V'a-ta to-ra, v'sha-ta l'ma-ya,
d'cha-va l'nu-ra, d'sa-raf l-chut-ra,
d'hee-ka l'chal-ba, d'na-shach l'shun-ra,
d'ach-la l'gad-ya,
D'za-been a-ba bit-ray zu-zay
Chad gad-ya, chad gad-ya

V'a-ta ha-sho-chayt, v'sha-chat l'to-ra,
d'sha-ta l'ma-ya,
d'cha-va l'nu-ra, d'sa-raf l'chut-ra,
d'hee-ka l'chal-ba, d'na-shach l'shun-ra,
d'ach-la l'gad-ya,
D'za-been a-ba bit-ray zu-zay
Chad gad-ya, chad gad-ya

V'a-ta mal-ach ha-ma-vet,
v'sha-chat l'sho-chayt,
d'sha-chat l'to-ra, d'sha-ta l'ma-ya,
d'cha-va l'nu-ra,
d'sa-raf l'chut-ra, d'hee-ka l'chal-ba,
d'na-shach l'shun-ra, d'ach-la l'gad-ya,
D'za-been a-ba bit-ray zu-zay
Chad gad-ya, chad gad-ya

V'a-ta ha-ka-dosh ba-ruch hu,
v'sha-chat l'mal-ach ha-ma-vet,
d-sha-chat l'sho-chayt, d'sha-chat l'to-ra,
d'sha-ta l'ma-ya, d'cha-va
l'nu-ra, d'sa-raf l'chut-ra, d'hee-ka l'chal-ba,
d'na-shach l'shun-ra,
d'ach-la l'gad-ya,
D'za-been a-ba bit-ray zu-zay
Chad gad-ya, chad gad-ya

PERMISSIONS

All of the photographs and illustrations used in this book are archival material from the American Jewish Joint Distribution Committee, Inc. Many of these photographs were commissioned by the American Jewish Joint Distribution Committee or taken by its staff members.

We wish to thank all of the institutions and individuals who graciously gave their permission to use photographs in this volume. The individual photo captions include the names of these institutions and individuals. We apologize in advance for any unintentional error or omission. If it should be brought to our attention, we will make all reasonable efforts to rectify the error or omission in any subsequent editions.

The following institutions and individuals generously granted permission to use photographs and images from their collections for this publication. Their assistance was invaluable in the completion of this book.

American Jewish Joint Distribution Committee Archives
Robert Belenky
Ofir Ben-Natan
Rick Hodes
Jewish Museum of Berlin, gift of Fred Kranz
Richard Lobell
Matzot Yehuda
Roy Mittelman
Peggy Myers
Donald M. Robinson
Kenneth Rubens
Michael Schneider
George Schnitzer
Edward Serotta
Shabobba® International, LLC, Dixie Henderson
The Manischewitz Company
UJA Archives

ABOUT THE JDC HAGGADAH

THE EXODUS STORY that we retell each year in the Passover Haggadah took place in Biblical times, but its lessons — of rescue, relief and renewal — echo throughout history.

This new Haggadah has a dual role. It includes the full traditional text, from *Kiddush* at the beginning of the seder to *Chad Gadya* at the end. In that sense, it retells the Exodus story the way it has been told for generations. But this Haggadah adds another dimension: It shows how the lessons of the Exodus story have been practiced with love and compassion in the modern era.

In Every Generation: The JDC Haggadah highlights the work of the American Jewish Joint Distribution Committee, which, since it was founded in 1914, has been the premier organization reaching out to Jews in distress around the world. For the making of this Haggadah, JDC opened its vast archives of photographs, letters and documents, many of them never before made public.

This Haggadah is rich in pictures of the rescue and relief of Jews in times of crisis — from pre-state Israel to post-*Shoah* Europe to Soviet Russia to the deserts of Ethiopia. It reminds us how the JDC helped liberate Jews in distress and provided for both their physical and spiritual needs. Some of the most moving images are of Jews who themselves narrowly escaped tragedy marking the Passover seder with the potent holiday symbols of matzah and wine.

The connections between the Exodus story and these modern-day rescues are made in the inspiring Foreword by Rabbi Joseph Telushkin and the insightful Commentary by Professor Ari L. Goldman. Historical anecdotes inserted at appropriate points in the text feature firsthand accounts by both rescuers and those rescued. Skillfully edited by Linda Levi, Director of Global Archives for the American Jewish Joint Distribution Committee (JDC), and JDC Consultant, Ilana Stern Kabak, what emerges is a vivid and moving account of the Exodus that reaches back through the ages and reminds us why the Passover story is a story for all times.

Photo: A.J. Goldmann

WORKING ON *The JDC Haggadah* has been a labor of love for two longtime friends, Professor Ari L. Goldman *(right)* and Rabbi Joseph Telushkin *(left)*. Each is prominent in his own field — Professor Goldman as a leading journalist and Rabbi Telushkin as a teacher of Judaism through such best-selling books as *Jewish Literacy*. Both are distinguished authors and sought-after lecturers.

For several years their families joined forces for Passover seders. Those seders were marked by lively discussions, dramatic readings and spirited singing, all of which served to make the ancient text come alive in the modern world.

In addition to his book *Jewish Literacy*, Rabbi Telushkin is the author of *A Code of Jewish Ethics, Volume 1 and Volume 2; Words* *That Hurt, Words That Heal; Biblical Literacy* and four novels. He lives in New York City with his wife, D'vorah Telushkin, and their four children.

Professor Goldman spent 20 years as a reporter for *The New York Times* before joining the faculty of Columbia University's Graduate School of Journalism. He is the author of *The Search for God at Harvard, Being Jewish and Living a Year of Kaddish*. He lives in New York City with his wife, Shira Dicker, and their three children.

Both Professor Goldman and Rabbi Telushkin serve on the board of the Jewish Book Council. They and JDC would like to thank the council's director, Carolyn Starman Hessel, for her guidance and dedication to this project.

IN PRAISE OF THE JDC HAGGADAH

*"The Rabbis in the Mishna – quoted by the Haggadah – mandated that
'in every generation each person should view himself/herself as if he/she just came out of Egypt.'
This JDC Haggadah demonstrates beautifully through commentary and story how the Joint
has translated this mandate into contemporary reality in its services all over the world,
in its commitment to a free, vibrant and stable Jewish community and in its threefold mission,
of Rescue, Relief and Renewal."*

– RABBI HASKEL LOOKSTEIN
Rabbi of Congregation Kehilath Jeshurun
and Principal of the Ramaz School, New York

*"No book has been more treasured in the Jewish home than the Haggadah and Jews have celebrated Passover
by illuminating and commenting upon its eternal tale of liberty in countless versions over the millennia.
Through its pictures and captions drawn from the archives of the JDC, this unique edition of this ancient text
portrays the variety and breadth of our people and communicates in a powerful and authentic voice the journey from
degradation to freedom that the Haggadah celebrates and that the Joint Distribution Committee makes possible.
It is a most welcome addition to liturgical expression in our time and will inspire and instruct countless Jews
and others gathered around the seder table for years to come."*

– RABBI DAVID ELLENSON, PH.D.
President of Hebrew Union College-
Jewish Institute of Religion

*"In pictures, words and prayers this unique Haggadah vividly reminds us that the story of our ancestors
is also our own story. A beautiful, eloquent example of renewing our ancient tradition."*

– RABBI DAVID WOLPE
Sinai Temple, Los Angeles